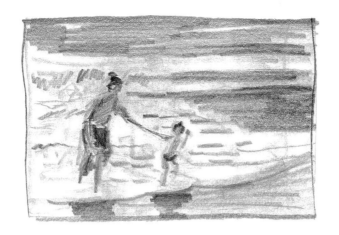

the Artist's Sketchbook

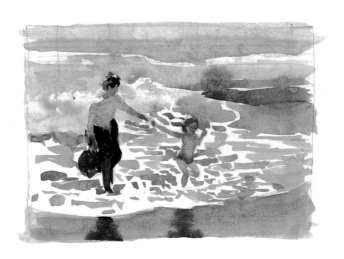

the Artist's

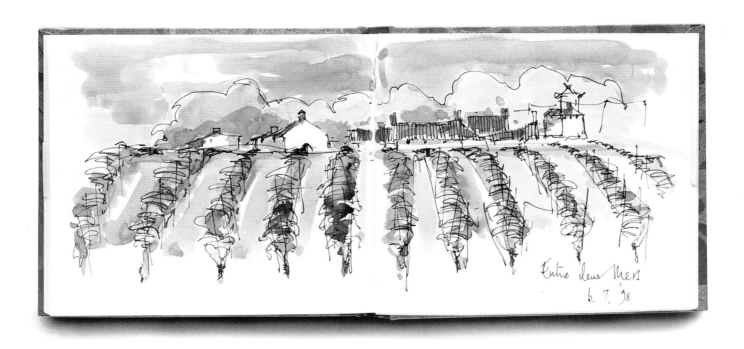

Entre deus Mers
6. 7. '98

Sketchbook

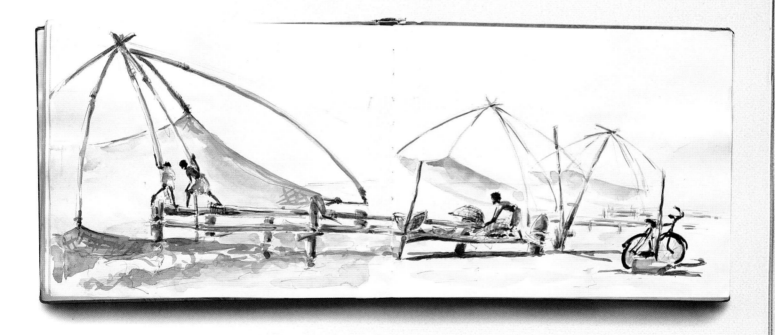

LUCY WATSON

NORTH LIGHT BOOKS

A QUARTO BOOK

First published in North America in 2001
by North Light Books,
an imprint of F&W Publications, Inc.,
1507 Dana Avenue
Cincinnati, OH 45207

ISBN 1-58180-211-0

QUAR.ARSK

Conceived, designed, and produced by
Quarto Publishing plc
The Old Brewery
6 Blundell Street
London N7 9BH

Senior Project Editor Nicolette Linton
Art Editors Caroline Hill, Jörn Kröger
Assistant Art Director Penny Cobb
Designers Mark Buckingham, Karin Skånberg
Photographers Martin Norris, Paul Forrester
Text Editors Claire Waite, Paula Regan
Indexer Pamela Ellis

Art Director Moira Clinch
Publisher Piers Spence

Manufactured by Regent Publishing Services Ltd,
Hong Kong
Printed by Leefung-Asco Printers Ltd, China

Author's Acknowledgments
I would like to dedicate this book to my mother
and thank all those artists who generously sub-
mitted their work for inclusion. And thanks must
go to my editor and the extensive design team
—led by the indefatigable and visionary Moira
Clinch—whose experience and expertise brought
the text and images so skilfully together.

Contents

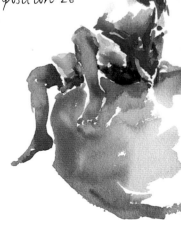

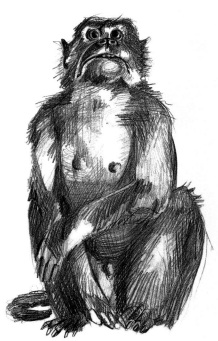

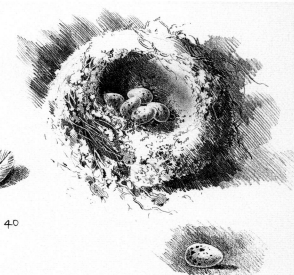

CHAPTER 2
sketching your subject
page 38

CHAPTER 3
from sketch to finished work
page 110

Sketching requires only the most basic tools, and is accessible to anyone who has the desire to give expression to their creativity. When asked how he started a drawing, an eight-year-old boy once said, "I think, then I draw a line around my think." By its very nature, the activity of sketching is not rigid. From the simplest imaginative jottings to considered studies for reference, sketching allows the artist to play with different techniques, compositions, and color combinations until something works. Even the most accomplished artist grapples with getting it right, yet unexpected and fortuitous discoveries can emerge along the way, and this is where the artist's sketchbook comes into its own.

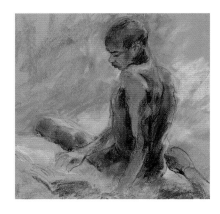

Far left: cone
media: pencil
The natural world has an infinite variety of textures and patterns to work with.

Left: nude study
media: pastel
The model's pose is still and brooding, yet the bright colors of the light reflected on his body and the broad strokes of pastel shading add a sense of restrained energy and drama.

INTRODUCTION
Thinking visually

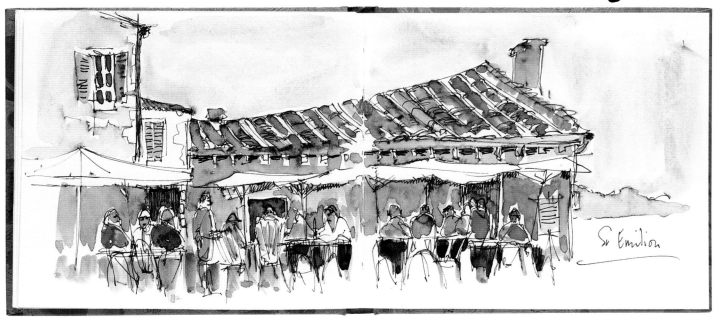

St Emilion

Left: irises
media: pencil
The artist obviously relished the detail in these irises, and managed to reflect their character and fragility perfectly with only a graphite pencil.

Opening up your sketchbook is like embarking on a voyage of discovery: you never quite know where the path will take you. It may lead down a blind alley, or to the heights of your own creativity. Always keep in mind that it is on this road that some of the most dynamic pieces of art have emerged. Experiment, observe, reconsider, rework, study, and start afresh, such is the freedom the artist enjoys within a sketchbook. As in everything, practice and perseverance will bring confidence, and with confidence you can explore new possibilities.

Adopt the habit of taking a pocket-sized sketchbook with you when you are out, reminding yourself every so often that drawing artwork does not follow a set of rules that must be slavishly learned and understood. What is more important is developing a keen sense of observation and visual awareness of the world around

you to which you can respond in your own unique way, through sketching. Regard your sketchbook as a private visual diary, a place where you can develop ideas from their very beginnings to a finished piece of artwork. Remember also, it is a place where you need never feel inhibited: in the sketchbook you are completely free to experiment, problem solve, and brainstorm.

However brief it is, a period of concentrated sketching will bring you extraordinarily close to your subject. You will find yourself becoming ever more sensitive to the excitement of colors, the subtlety of light effects, the tactile qualities of texture and form, even a familiar face seen in a different light. Monet, the French impressionist artist, said after being taken on a sketching trip as a young man by the older master, Boudin,

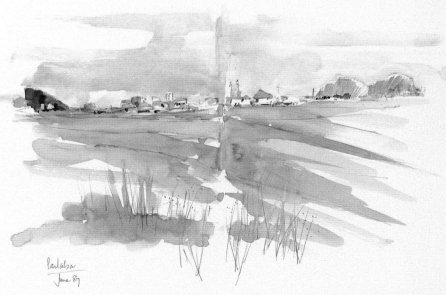

Left: eating *al fresco*
media: watercolor and ink
The bright accents of red and yellow used to depict the customers at this relaxed outdoor restaurant create a sense of animation against the subdued earth tones of the setting.

Right: rural view
media: watercolor and pencil
The composition of this picture is divided into three distinct areas: in the foreground are grassy tufts, and in the middle is the great expanse of field, which extends to the line of houses on the horizon.

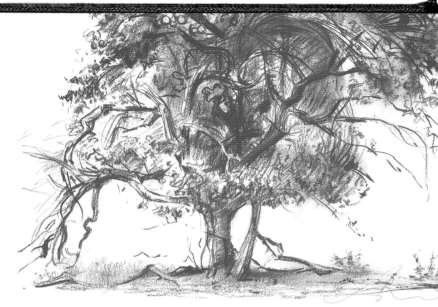

"It was as if a veil has been torn from my eyes and suddenly I could see." Like Monet, the everyday world we encounter can be transformed into a more exciting place when we really begin to observe our subject and learn how to record our visual experiences.

Within the leaves of my sketchbook there is a travelog of places I can revisit that includes recollections of faces familiar and unknown, a study of trees bent in the wind, the texture of a tiger's coat, and the notations for an idea for a painting once abandoned but that I have now come back to and will pursue. The artist's sketchbook is a place to explore, a mine of inspiration always holding the promise of more things to come.

Below: washing clothes in the river
media: watercolor
The artist gives life and depth to this piece with reflections in the water of colorful clothes, a car, and the pillars of an imposing building in the background.

Above: study of a tree
media: chalk
A variety of marks made with red chalk of fine wisps, chunky scribbles, and smudges work together to portray a tree that almost bursts from the page. The gestural swirls and vigorously hatched marks give a great sense of movement within the foliage.

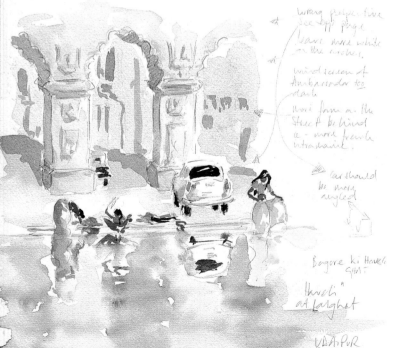

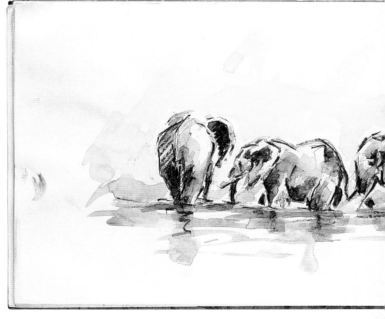

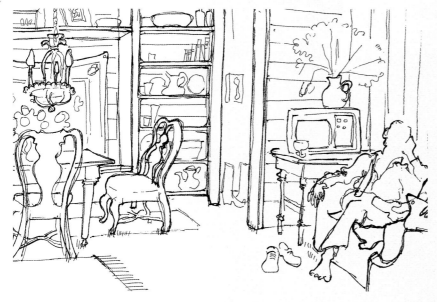

Left: at home
media: pen and ink
The artist has let a line meander around the interior of the room, encompassing the myriad objects and the figure in simple outline.

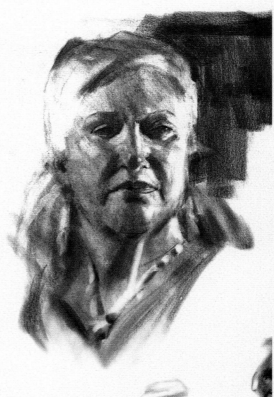

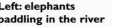

**Left: elephants
paddling in the river**
media: watercolor
This lively sketch shows the expressive use of contrasting color temperatures: the warm yellow sky juxtaposes with the cool blue of the water.

Above: reflective mood
media: conté
Shadows are roughly blocked in on the brightest side of the face to emphasize the fall of light, thereby creating a strong three-dimensional effect.

CHAPTER 1 # Making

Never before has there been such a huge choice of materials available to the artist. Almost all media comes in different ranges, different grades, and a vast array of colors, tints, and sizes. It is worth spending some time in a large specialized art store to familiarize yourself with the materials available. The employees—often artists themselves—are usually knowledgeable about their stock, and information on how a medium can be used is frequently supplied with the

your mark

product. The following pages discuss the most-used media—as well as the basic principles of perspective, composition, light and tone, and color—but experimenting with as many materials and breaking a few rules is really the only way of finding out what works best for you. Remember though, sketching need not be an expensive or even time-consuming hobby: some of the greatest artwork has been created in a matter of minutes with nothing more than a humble pencil.

Dry media

Most dry media are available in a range of hard and soft textures, and a wide variety of tones and colors. To make the most of your money—and for flexibility—buy pencils and pastels singly, rather than in boxed sets.

soft

medium

hard

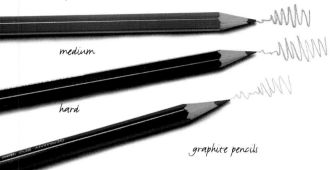

graphite pencils

Graphite pencils and sticks

A graphite pencil is one of the most commonly used tools for sketching and is very versatile. With the large range of grades available, you can create the most delicate and subtle tones using the harder leads, to dark and vigorous with the softer. The thicker graphite sticks can be used to cover larger areas.

8B is the softest and darkest lead available; 8H, at the other end of the range, is the hardest and lightest. HB is in the middle of the range. It is useful to keep a variety of leads since different sketch work will require different tones. A small, useful selection of pencils to start with includes a 2B, 6B, HB, and 2H.

Charcoal

Available in various sizes and thickness, charcoal is particularly suitable for larger drawing and free sketch work. Experiment with just one stick on a selection of smooth and rough textured papers, and discover the different marks it can make. You will find you can work from the darkest shades of black to subtle grays by just smudging a line with your finger. With charcoal, you can produce sweeping lines like brushstrokes, or, by using a stick on its side, you can rapidly block in large areas of tone.

enliven a scene with vigorous pencil marks

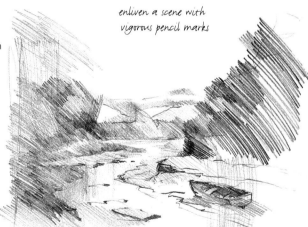

Right: stranded boat
media: graphite pencil
By alternating between hard and soft pressure on the pencil lead, a large variety of dark and light tones can be achieved with one pencil. 2B is a good all-rounder to try out this technique.

charcoal

Hard or compressed charcoal and charcoal pencils

These are ideal for general sketching purposes, for making preliminary sketches under chalk pastel work, sharpening definition, and adding fine details to finished work.

rough strokes of color facing a multitude of directions give the work texture and suggest light falling through the tree onto the path

Chalk pastels

Chalk pastels are available in different sizes, grades of softness, and in a large variety of colors and tints. As with charcoal, hard chalk pastels can be used for linear sketch work, preliminary drawing, and adding detail and highlights to your finished work. Stunning color effects can be achieved by blending soft chalk pastels. You may require several sticks of a single color that features a lot in your work since soft pastels can be quite crumbly and wear down very quickly.

chalk pastels

Tip: *Working with pastels is messy, so keep yourself clean by wearing an old shirt and invest in some wet hand wipes. Store pastels in a container padded with soft tissue to protect them from breaking.*

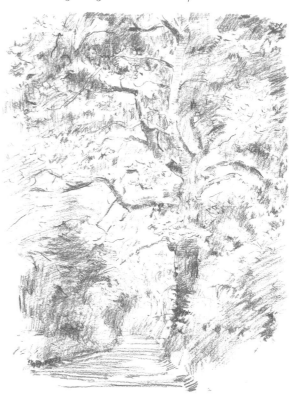

Right: down the lane
media: chalk pastel
The vast tree acts as a device to bring a great sense of depth to this landscape study. As it almost bursts out of the page in the foreground, the shrubbery and path recede behind it into the distance.

FIXING

To fix chalk pastel and charcoal work, a bought aerosol fixative is best, although hair spray is a cheaper but inferior alternative. Spray evenly over your work but don't get carried away—fixing has a dulling effect on pastel work. Interleave your sketch work with tissue paper; use acid-free tissue paper if you intend to store your work interleaved, because even work that has been fixed will still smudge a little. Remember to work in a well-ventilated room or even cover your nose and mouth with a mask—the best types of mask accept a filter cartridge.

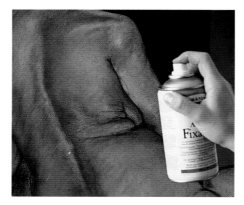

Oil pastels

As with chalk pastels, oil pastels can be bought in many colors and grades of softness. Some are so soft they have an almost creamy texture and can be smeared with the finger, especially on a warm day when they begin to melt.

Once you have made your mark with an oil pastel it cannot be easily removed. It is therefore better to make a light preliminary sketch of your work in pencil or compressed charcoal before you commit your oil pastels to paper. You can blend colors by overlaying soft oil pastels on top of one another, but limit the number of colors you use to keep them fresh and vibrant.

oil pastels

Colored pencils

There is now a vast selection of colored pencils on the market; these are different from water-soluble pencils (see page 18). They are used for sketching in much the same way as the graphite pencil. A good quality range will give vibrant or delicate tones and, of course, introduce the element of color to your sketch work.

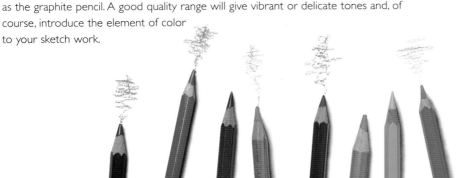

colored pencils

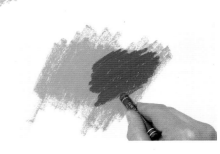

BLENDING

Soft media like chalk or oil pastels can be laid down next to or on top of each other and blended together to create stunning color effects. For chalk pastel, use your fingers, a tortillon (tight roll of paper), or cotton swabs to blend small areas, and a soft rag for large sections. You can create some interesting effects with oil pastels by putting down two or three layers of color and then scraping back or drawing into the top layer using a blunt point, to reveal the colors beneath (see above).

Commercial pens, ballpoints, fiber-tips, and markers

These can all be used to make fast and lively work. They are particularly suitable for a doodle style of linear sketching. As they can be bought so cheaply, try out a variety and experiment until you find a selection that suits your style. Some are water soluble and can be used to good effect in creating tonal washes.

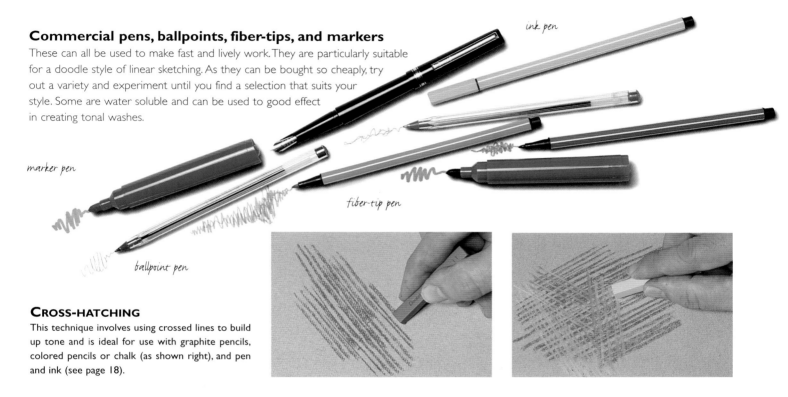

ink pen

marker pen

fiber-tip pen

ballpoint pen

CROSS-HATCHING

This technique involves using crossed lines to build up tone and is ideal for use with graphite pencils, colored pencils or chalk (as shown right), and pen and ink (see page 18).

ERASER TECHNIQUES

An eraser can be a very useful tool, not just for rubbing out mistakes, but also for creating areas of highlight, as shown left. A putty eraser is very soft and can be kneaded into a point to pick out areas of fine highlighted detail. Try rubbing a fine layer of charcoal, pastel, or graphite onto a sheet of watercolor paper; do not apply too much or you will find it difficult to remove. You can now experiment with drawing into the mark with an eraser. Your first attempts at rubbing away will be the freshest and brightest, however, overworking areas again and again with the eraser will muddy your sketch.

Wet media

Watercolor

Watercolor paints are available in tubes or in tablets, also known as pans. The paint is mixed with varying amounts of water to create different colors and degrees of transparency. Watercolor is versatile and can be used on its own or as an accompaniment to pencil sketches or pen and ink work. Ideally the medium should be used on watercolor paper, usually brilliant white in color and requiring stretching before use (see page 17).

Traditionally watercolor is worked from light to dark, allowing the brightness of the paper to shine through the colors. While there are no set rules, think of working with watercolors as using colored light. This medium really works best in its purity, transparency, and freshness. To keep your colors fresh, change your mixing water frequently.

Watercolor paintings are often built up in washes, and white highlights will appear sharper if derived from untouched paper rather than from white paint. A preliminary sketch will give you the necessary information to plan a finished work, and masking fluid applied at the beginning will help you to retain areas of highlight (see right).

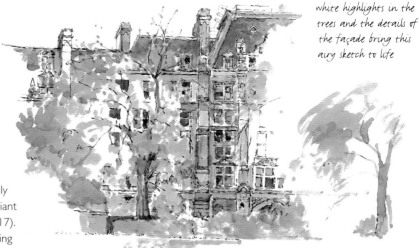

white highlights in the trees and the details of the façade bring this airy sketch to life

Above: shady street

media: mixed media
The watercolor study of a street scene shows how light effects can be conveyed using a restricted palette.

Brushes

There is an enormous range of brushes of different sizes and quality available. These range from the finest sable brushes that are capable of making a mark the size of a pinprick, to large brushes for applying ample color washes.

All you will require for general sketching purposes is a selection of three brushes: a fine one for adding details, a medium size brush for general use, and a larger size for washes. You can purchase a relatively inexpensive synthetic brush, or a more costly sable one that will last for years if you take good care of it.

MASKING FLUID

With a brush, sparingly apply masking fluid to areas you wish to mask. When the liquid has dried, continue the watercolor, painting over the rubbery masking substance. When the painting is dry, peel off the substance to reveal the protected areas.

brushes

watercolor pan

watercolor tube

Tip: Never leave a sable brush soaking in a jar of water, the fine hairs will bend and dry out of shape. If you intend to carry sable brushes around, to work outside, for instance, protect them by rolling a small piece of paper around the bristles and secure it with tape.

WET ON WET

Working wet on wet gives watercolor painting its luminosity. Stretch your watercolor paper and use a large soft brush to apply clean water all over. Let the water soak in for a few seconds and start to experiment by adding mixed watercolor paints to your wet paper, as shown right. Notice how the colors diffuse and stain. Lay colors next to each other and let them overlap, they will bleed into one another to create color mixes.

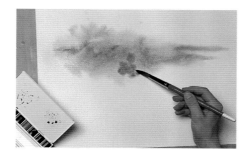

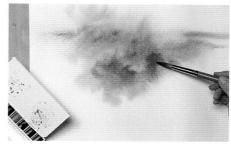

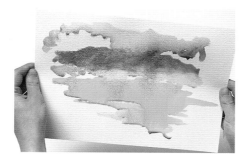

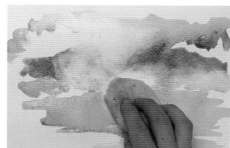

WATERCOLOR WASHES

A watercolor wash is the wet on wet application of diluted watercolor paint. Washes are ideal for steeping large areas of your work in color, such as sky or water. You can control this diffusing and bleeding by tilting your paper, teasing the colors along with a soft brush, and dabbing trails with a small natural sponge (as shown left). You can make a fluid piece of work by continuing to work wet on wet, or you can let the underlying wash dry first.

STRETCHING PAPER

You can buy pads of prestretched watercolor paper or stretch it yourself at home. Immerse the sheet of paper in a tray of water. When it is saturated (after about a minute), pick up the paper by two corners and let the excess water drain off. Lay the sheet, right side up, on a clean drawing board. Smooth the paper down with a clean, dry cloth to disperse any air pockets. Take a 2 inch (5cm) wide gum tape, tear off four strips—one for each edge—about 2 inches (5cm) longer than the length of each paper edge. Moisten one strip at a time and lay about 1 inch (2.5cm) over the paper, sticking the rest on the board. Smooth it down firmly with the cloth and leave it to dry flat. When it is dry, it is ready to use.

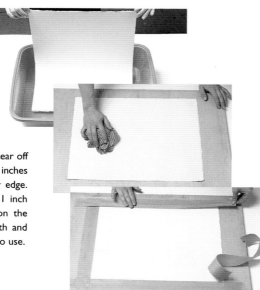

Tip: A small natural sponge is great for removing watercolors while they are still wet, and to soak up dribbles. When working with any water-based media, keep a box of tissues handy to soak up the excess on a loaded brush, and for cleaning brushes and drying dip pens when you have finished work.

17

Water-soluble pens and pencils

Water-soluble pens and pencils are excellent for softening linear work and they can be used to add areas of tone by working through the lines with a wet brush. Water-soluble pencils are ideal for outdoor projects because they are portable and easy to use. They tend to be sticky in texture and are difficult to erase if you make a mistake, but a good quality range will allow you to make quick color reference notes and bring watercolor effects to your sketch work.

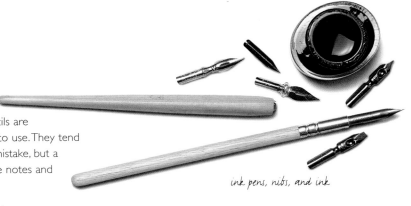

ink pens, nibs, and ink

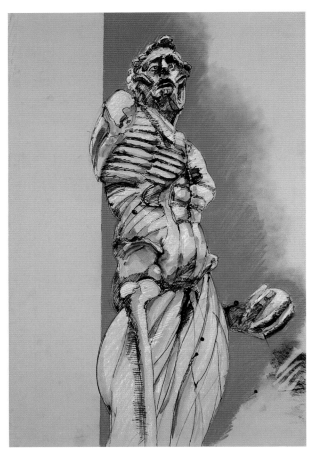

a mixture of pen and ink, watercolor, and chalk pastel bring color and add dimension to the sketch

Left: statue of a "flayed" man

media: mixed media

Art students throughout history used the statue of a flayed man to study the anatomical structure of the human body. After making detailed anatomical studies of this piece, the artist decided to experiment with a mixture of media to create an image in its own right.

Ink

Colored inks can be used in a similar way to watercolors and applied with a brush or used with a dip pen for linear sketching and cross-hatching. Washes in diluted ink can be applied to a sketch to add areas of tone.

For sketching with a dip pen, you will need a penholder that sits comfortably in your hand and a selection of nibs that slot in one end. There is a bewildering selection of nibs available for pen and ink techniques and all make different types of mark, while the paper you work on will also affect your work. Smooth paper and a fine nib should be used for careful, detailed work, while rough paper can cause nibs to scratch and spatter, effects that have been exploited by cartoonists to bring a wonderfully expressive dimension to their work. Fortunately nibs bought alone are not expensive, test some out on a variety of paper scraps to find those that best suit your style of working.

Gouache

Gouache is a form of watercolor paint, but where watercolor gives a transparent effect, gouache is opaque. It dries fairly rapidly and is ideal for laying down areas of flat color. It can be used effectively in combinations with other media such as ink, charcoal, and pastels.

gouache tubes

a sketchbook will begin to reflect
an artist's personality—here, collage, ink, and gouache show
the artist's interest in diverse images, ideas, and media

Right: example of a sketchbook
media: mixed media
A brainstorming page of ideas, newspaper snippets, and scribbled text in a sketchbook. Incongruous fragments, perhaps, but inspirational as a whole.

MIXING MEDIA

You can achieve some unusual and exciting effects by combining media, as shown here with oil pastel and watercolor. Experiment with a combination of materials, both wet and dry together.

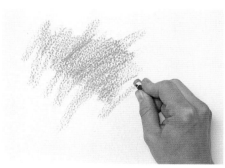

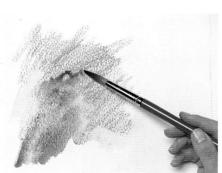

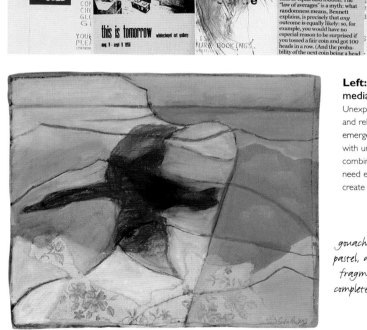

Left: goose in flight
media: mixed media
Unexpected discoveries and relationships can emerge by experimenting with unconventional combinations—you don't need expensive materials to create an effective piece.

gouache, charcoal, chalk pastel, and even a torn fragment of wallpaper, complete the piece

19

Choosing papers

Papers can be bought in varying weights from heavy to light. Different media are better suited for use on particular papers so it is useful to have a selection on hand.

A heavyweight paper, such as a watercolor paper, allows for reworking, erasing, and blending so is good for studied sketches as well as work with water-based media. Lightweight papers are ideal for quick sketching with charcoals, and brush and ink.

Cartridge is a good paper for general sketching use. A heavier weight of cartridge is ideal for all dry media sketching, while a cheaper and more lightweight paper such as printer's paper can be used for working out ideas and problem solving. Tone-colored cartridge papers have a slight texture, or tooth, and are particularly suited to work with charcoal, chalk, and oil pastels. Bright colors appear to glow when used on darker shades of paper, and you might choose to exploit this in your work so that the tone of the paper becomes an integral part of your finished piece. There are a large variety of toned papers available, or you can create your own toned paper by laying a watercolor wash on white paper (see *Watercolor washes*, page 17).

Some papers look enticing but are so soft they tear if you take a stick of chalk or an eraser to them. Others don't absorb water well, so are

of no use for water-based media, while some may absorb water so quickly they allow no working time. There are so many types of paper available it is only by trial and error that you will find the ones that work for you. Some specialist art stores will supply small books of paper samples for you to try out; or you can buy just one or two sheets at a time.

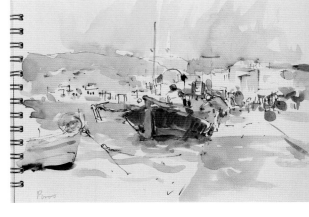

Above: boats in a safe harbor
media: mixed media
A pad of thick, stiff watercolor paper makes an ideal ground for sketching with wet media. Small sheets of heavier weight paper will not require stretching before use.

the warm color of the ground provides a contrast with the cool blue tones and pale highlights

Above: young dancer
media: chalk pastel
Imagine the same subject but on a white background and you will see how much the body color of this inexpensive paper affects the work.

a range of papers including tinted, rough, and smooth

Tip: Some papers carry a watermark. Hold up a sheet to the light, and if the letters read the right way round you are looking at the correct side to use.

Working out and about

Take a little time to consider your aims and the tools you will need to achieve them; this can make the difference between a day of effective working or one where you are encumbered with stuff but don't have the right tool handy when you most need it. Of course you can't anticipate what discoveries you'll make out there, so it is wise to carry a small range of media to suit most purposes.

It is also good practice when you are out and about to fill at least one page with visual information on any chosen subject. Try making studies of your subject from various angles and in different compositional arrangements. Make notes to yourself on colors and textures, and what it was that inspired you to stop and sketch your scene or object. You will be surprised how useful all this data is in recalling your day's sketching at a later stage, and you will always have enough visual information to take your sketch into further work if you so decide.

Below: inspiration
media: mixed media
A sketchbook of text, tracings, color, and disparate images make a visually exciting page of ideas.

collaging details and fragments can give rise to interesting compositions; and areas that work well can always be taken into further work

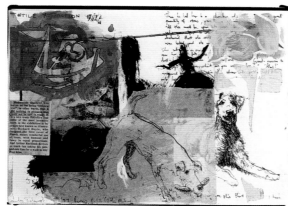

A good outdoor kit to start with might hold the following:

* A handheld or lap-size book with a stiff backboard to lean on, or a piece of hardboard and a bulldog clip

* A handmade viewfinder (see page 28)

* Four graphite pencils, 2H, HB, 2B, 6B

* Three or four sticks of charcoal, hard and soft

* An eraser

* Watercolor paints, a small tin of tablets, ideally with a metal palette attached

* Water-soluble pen

* Water-soluble colored pencils; you can sketch in the structure using the pencil then brush over with water to create watercolor effects. Also useful for recording color reference

* Chalk or oil pastels, ideal for color reference to take into further work

* Sketchbook of prestretched watercolor paper, or pages of paper you have stretched yourself (see page 17)

* Cartridge paper, natural and toned

* Tissues

* Small natural sponge

* Craft knife with retractable blade

* Three brushes, fine, medium, and large

* Screw-top jar of clean water, two if you know you won't be able to access clean water on site

* Small palette or saucer

* Can of aerosol fixative

* Precut sheets of tissue paper to interleave charcoal and chalk and oil pastel work

* Wet hand wipes

* Camera (optional)

* Folding fisherman's stool, or a small cushion in a plastic bag if you don't mind sitting on the ground

* Small portfolio if carrying loose leaves of paper

* Fingerless gloves; in cold weather it is very difficult to work with cold hands

* Charcoal burning pocket hand warmer

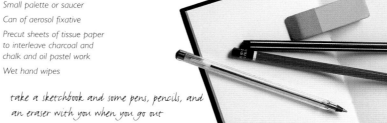

take a sketchbook and some pens, pencils, and an eraser with you when you go out

21

Understanding perspective

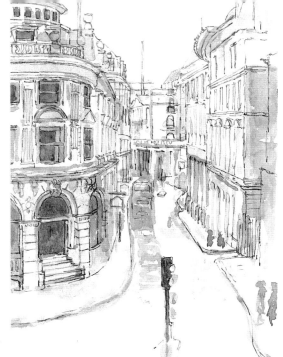

Over the centuries, artists have devised many complex geometrical schemes to achieve the illusion of three-dimensional depth and space on the flat surface of their pictures. It is also quite obvious that many artists, particularly those working in the twentieth century, have chosen to ignore these schemes completely. Their primary aim is to create visually exciting images from original ideas. Since this is the main aim of putting pen or pencil to paper, we should not regard the principles of perspective as a set of rules never to be broken. However, a basic understanding can be useful in enabling you to translate the three-dimensional world you see all around you onto the flat, two-dimensional page.

Once you have gained some confidence in handling basic perspective and know that you can make what you see look right in your sketchbook, you can then be inventive with it, or dispense with it, if that suits your style. If, on the other hand, you feel perspective will play

Right: city street
media: watercolor
The perspective of the buildings on either side slope down toward their vanishing point, leading the eye straight down the street and into the distance.

a single street has a similar perspective to an interior room

an important part in your work, you can take your studies further with the help of the numerous books written on the subject. Here, to get you started, are some techniques to try that will enable you to achieve the illusion of space, depth, and distance in your work.

Perspective, in its simplest form, means that the further things are from us the smaller they appear. It relies on two things, your eye level in relation to the object you are looking at or the scene in front of you,

Perspective in principle
You will see from these simple diagrams how the basic principles of perspective work and how they can create a sense of depth and space in a composition. When you start to apply these to your work, you can use your pencil to check your angles of perspective are following the correct directions (see *The Pencil Method* on page 25).

One-point perspective

Imagine being in a room with a door on one wall and a window opposite. You are sitting on the floor in the middle, looking at the far wall.

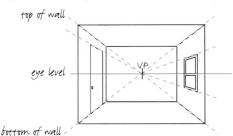

If you plot the position of the receding horizontals above and below the tops of the walls, door, and window, and continue drawing them, they will converge at the vanishing point (VP) at eye level on the far wall.

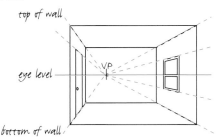

If you move to one side—let's say to the left—the lines of perspective and the vanishing point will change to correspond with your new viewpoint.

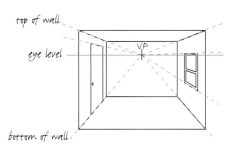

If you stand on a chair, again, the lines of perspective and the vanishing point will change to correspond with your new viewpoint.

similar to a cube, the walls of the building in this sketch become smaller the further away they are from the viewer

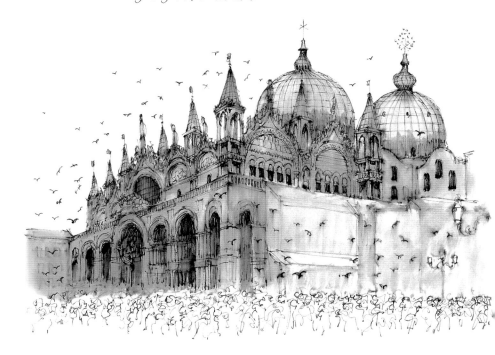

Right: St Mark's, Venice
media: pen and ink
The walls of St Mark's basilica loom up, towering above the crowd gathered on the piazza below, giving the building a sense of grandeur and importance.

and the distance you are away from it. Take a moment to carry out the experiments in one-point and two-point perspective shown below.

We know that in the world of three-dimensional reality the lines representing the walls, ceilings, and floors in the diagram would be parallel, but as we translate them into two dimensions in the sketchbook, these parallel lines appear to be coming together. If we carried on drawing them they would appear to recede and eventually converge to a point at eye level and on the horizon line. This converging point is known as the vanishing point. The walls are not, of course, getting shorter, even though our eyes seem to be telling us so. The same rules apply whether you are looking at the outside of a building from an angle or whether you are inside an interior space.

Two-point perspective

Find a simple shape, like a cube or box, and try this experiment:

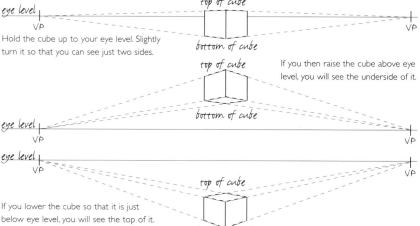

Hold the cube up to your eye level. Slightly turn it so that you can see just two sides.

If you then raise the cube above eye level, you will see the underside of it.

If you lower the cube so that it is just below eye level, you will see the top of it.

Now imagine that the cube is a building and you are looking at it straight on so that you see only one façade. In this position, the "building" will not be seen in perspective.

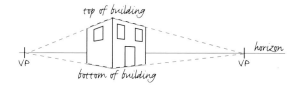

Move around the "building" so that you face a corner and can now see two sides. Notice how this corner appears to be the highest point of the structure; this is because this corner is closest to you.

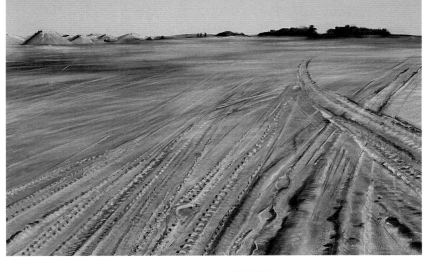

tracks left behind by passing vehicles provide lines that lead the eye toward a distant horizon

Leading lines

Lines in the landscape, such as buildings, streets, tracks, and furrows, can lead the eye into your work, taking it from foreground to background. The vanishing point lends a strong pull on the eye that can help create a dynamic composition even if it lies beyond the picture area.

Layering effect

By overlapping subjects in your work, layering them one in front of the other, you can create the illusion of three-dimensional depth. This creates a sense of perspective in two ways: firstly, items that overlap must obviously be in front, and therefore will be bigger than the smaller receding objects. In a landscape, trees, clouds, and houses could all be subject to layering in this way.

Right: clouds
media: chalk pastel
Layers of clouds are stacked in the sky, becoming increasingly larger as they appear to move toward the viewer. This stacking of objects can create a dramatic sense of depth in your work.

Above: natural leading lines in *Exodus*
media: chalk pastel
This sketch makes use of the disappearing lines in dust to create the illusion of depth and space. Look for lines and directions that can lead your eye through a landscape to create a sense of distance.

the dark trees on the horizon and brooding gray skies give the air of an impending storm

the pencil is ideal for showing aerial perspective, as it can produce a wide range of tones

Right: country view
media: pencil
Compare the fine detail of the roof tiles in the foreground with the building standing behind. The second building is paler and the landscape behind that paler still, giving a subtle look of recession.

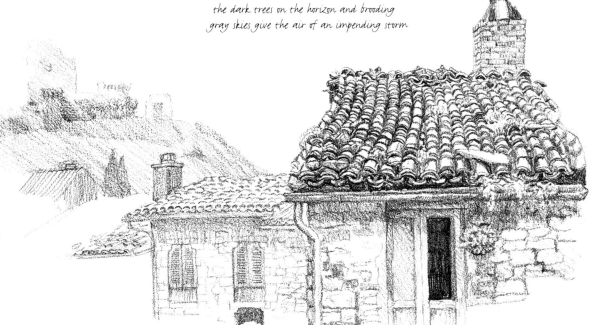

24

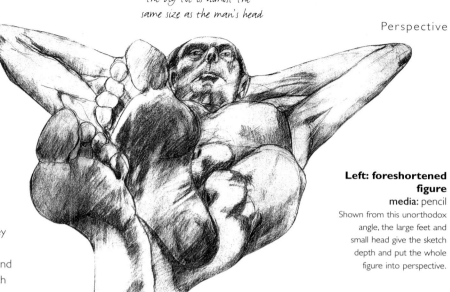

the big toe is almost the same size as the man's head

Foreshortening

Get used to looking out for perspective in the world around you. Familiarity with it will attune your eye to seeing the principles mirrored in just about everything you see—even in people, when you see the figure foreshortened (see *Mastering the Figure*, page 78).

Aerial or atmospheric perspective

Features in a landscape appear to become paler as they recede into the distance and we view them through layers of atmosphere. Lightening the definition of line and color as it recedes into the background, contrasted with sharper definition of objects in the foreground, will create the illusion of space and depth.

Left: foreshortened figure
media: pencil
Shown from this unorthodox angle, the large feet and small head give the sketch depth and put the whole figure into perspective.

CHECKING PERSPECTIVE BY THE PENCIL METHOD

It is useful to check your lines and angles of perspective by measuring with your pencil; this will help you to estimate the extent and direction of tilting lines. With some practice, your eye will become accustomed to seeing the world in relation to the principles of perspective as it exists all around us.

photography is a useful tool in judging perspective

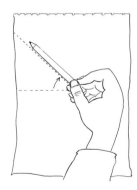

Hold your pencil at arm's length in front of you, first keeping it vertical. Close one eye, incline your pencil against the tilting lines along the edges of buildings, roads, doors, and estimate the angle.

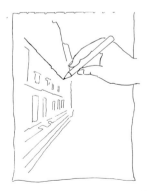

When you have estimated the angle of the tilt, transfer it to your work. Keep reviewing your angles with the pencil. You can build up much of your work in this way.

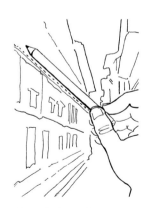

Notice how the lines of perspective on objects above your eye level will point downward toward the vanishing point (VP), and those below it will appear to point up to it.

Understanding composition

Many books have been written about the methods of compositional construction that the Renaissance masters devised to ensure their works embodied the ideal of perfection and beauty. The Golden Section is one of the most well known of such compositional devices, based on mathematical proportions. It was thought to have a divine significance that corresponded to the mathematical laws which governed the creation of the universe. Although this is now no more than an interesting historical fact, it is still useful to sketch from these paintings, in a gallery or from reproduction, to discover for yourself the underlying geometry of the composition, looking for circles, squares, and triangles that form the structure of the work. These simple shapes can create a feeling of stability and order, or one of dynamic movement within the picture.

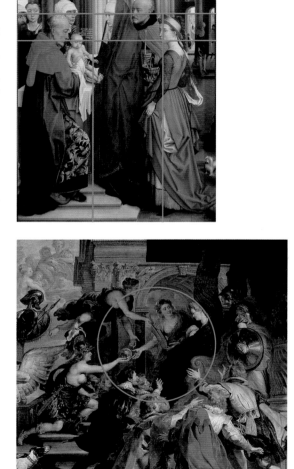

Right: Rogier van der Weyden, *Presentation in the Temple*

The eye is drawn upward toward the illuminated, vaulted ceiling suggesting the presence of God in this formal but intimate scene gathered around the baby Jesus. An underlying rectangular composition creates a sense of dignity and order.

Compositional shapes

Try to plot key reference points in a painting's design. Follow, for example, the curve of torsos, the sweep of limbs, the gestures of figures, the direction of their gaze, the flow of drapery, even the branches of trees and placement of buildings. Throughout the history of Western art, however, rules were made only to be broken by new generations of artists who sought experimental methods of working. Perspective was distorted, forms exaggerated, and images cropped off at the edges, taking the eye beyond the picture frame to heighten the sense of drama and movement. Work became composed more intuitively.

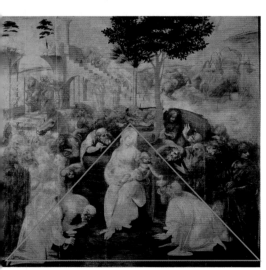

Above: Leonardo da Vinci, *Adoration of the Magi*

The foreground figures are arranged within a triangular composition. The Virgin's head at the apex becomes a focal point.

Above: Peter Paul Rubens, detail from *The Apotheosis of Henri IV and the Proclamation of the Regency*

We follow the gaze and beckoning gestures of the figures that surround Marie de Medici, who sits enthroned and framed by a triumphal arch.

COMPOSITION IN PRACTICE

The same principles apply when deciding on a composition for a sketch, although one shouldn't be too rigid when sketching, as this is where your "thinking" takes place. In general, try to create an interesting pathway for the viewer's eye to gradually comprehend the whole sketch, while the shapes within the sketch should balance each other.

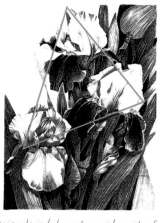

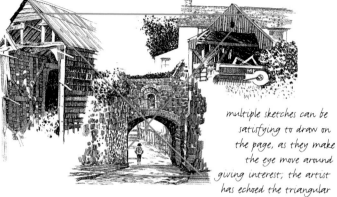

a triangle is balanced on either side of the center point, but so it is not too level the heights of the iris are staggered

multiple sketches can be satisfying to draw on the page, as they make the eye move around giving interest; the artist has echoed the triangular architectural shapes in the composition

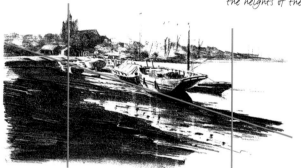

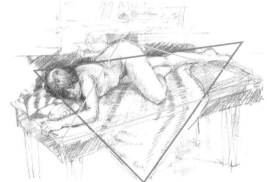

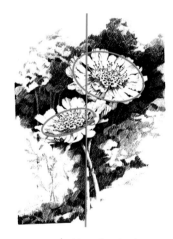

the viewer's eye is led diagonally into the distance—from the large foregound boats at a quarter point to the church spire at the other quarterpoint—creating a balance

at first glance, this sketch looks as if it was based on one triangular composition, but an inverted extra triangle adds more interst to the surface arrangement

the idea of a simple central image is generally considered boring in terms of composition; however, here the artist has created interest by placing two staggered flowers with their heads at different angles on either side of the central vertical line

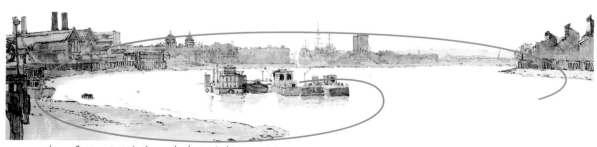

a large flattened circle forms the basis of this composition leading the eye around to the central focal point

27

Creating your own compositions

You should try experimenting with composition yourself. A particularly useful and simple tool to help you do this is the viewfinder. Take a look at your subject through the viewfinder and move it around as you would a camera lens to compose a photograph. If your subject is a landscape, see how different the scene looks with more sky or by moving the viewfinder down. Now focus on the foreground with just a strip of sky. Take in a feature from your landscape, such as a tree or house, position it in the middle, now sit it on one side. Does this work better? If your subject is a figure in a room, move your viewfinder around the figure, include a window, more or less of the floor perhaps, turn your viewfinder around to alternate between a landscape or a portrait format. Which seems more satisfying to the eye? You will probably find a composition works better if your focal point or horizon line is not placed right in the middle; symmetry can be rather boring.

Create at least three or four thumbnail sketches from the image you see through the viewfinder. You will soon discover that some compositional arrangements are more exciting than others. Some might achieve a sense of balance and tranquility, others could appear discordant but be visually dynamic. Both can work depending on the impression you are trying to capture. Whatever it is that makes one composition work and another fail, cannot always be put into words. It can just be a matter of minor adjustment, the addition of something in one area, the elimination of something else in another. By playing with the arrangement, you will discover that certain adjustments can make the composition of the scene more dynamic or ordered. Most importantly, don't be too exacting, have fun with it; a composition can, and often does, suddenly fall into place when you least expect it.

HOW TO MAKE A VIEWFINDER

Take a piece of card approximately 10 inches (25cm) square—the side of a cereal box is ideal for this purpose. Measure and cut out two "L" shapes about 10 inches (25cm) long and 1½ inches (4cm) wide. Put the two "L" shapes together so they form a square, with an aperture or hole in the center. Open and close the aperture by sliding the "L" shapes together, or pull them further apart. View your image through the aperture and select your composition.

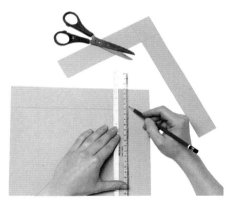

use your viewfinder to compose a piece of work by framing what you see when you are out sketching; by the same method, select specific areas of your sketch or photograph, to focus on interesting details to develop

zooming in on the two figures in the distance makes them a focus of this landscape sketch

DEVELOPING A COMPOSITION

In this freely hatched sketch of trees seen through sunlight, the long shadows in the foreground are an important element, heightening a sense of three-demensional depth.

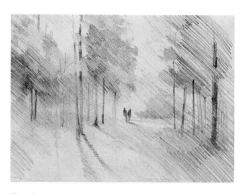

Two figures are introduced slightly off center. The sketch is evenly balanced yet not symmetrical, which could have made it rather dull and predictable. .

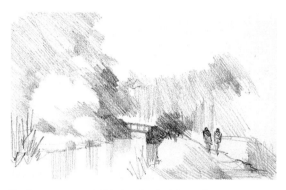

The figures appear again. This time they lead the eye in a sweeping direction from right to left over the little bridge across the water.

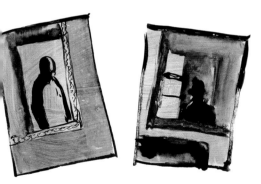

FROM THUMBNAIL TO SKETCH

Develop your more successful thumbnail sketches into larger pieces. These could provide good reference material for further, more ambitious work. It is worth reminding yourself, however, that often it is a case of less is more, and keeping your composition uncluttered can be infinitely more successful than trying to cram in a host of details that can so easily lead to visual confusion. Use artistic license if you need to, you don't have to include everything just because it is there, a composition can be complete in its very simplicity.

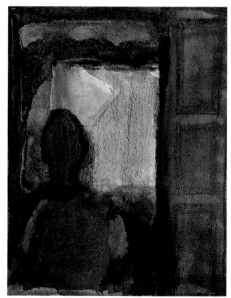

The mysterious presence of a person looms up in a mirror. The light from the window throws the figure into shadowy profile and we seem to be viewing the figure from behind.

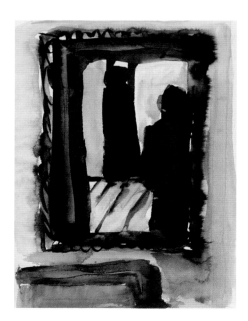

In this sketch, the mirror becomes central to the composition and more of the room is reflected. Each reworking of the theme achieves a different impact (left).

Light and tone

Without light there is simply darkness, so the appearance of everything around us is affected by the fall of light. Light and tone give a sense of three-dimensional solidity to the subjects we draw. Think of the light on a sunny day, so dazzling that we screw up our eyes against it. It almost bleaches the surfaces it hits in a blinding brightness. The shadows cast are sharp and dark. On an overcast day, by contrast, the fall of light and shadow can be so subtle it is difficult to make them out at all. Areas of light and tone on your subject can be further disguised by the distraction of a variety of surfaces, each having tonal values of their own.

notice how the artist has left areas of the paper untouched to convey bright highlights, particularly where she depicts water

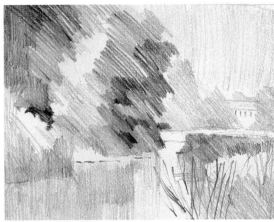

Above and right: water meadows
media: photograph and pencil
This sketch shows how the artist has realized this photographic scene of water meadows by using a graphite pencil to hatch areas of light and tone. The result is a delicate drawing that captures—and enhances—the tranquil ambience of the setting.

To translate tonal values within our sketches we need to transform what we see to tones of black, white, and gray, like an old movie. If you half close your eyes to look at your subject the contrast of light and tone will become more obvious, so consciously remember to do this as you work.

Natural light

Natural light is always changing. When you set up a still life or the study of a figure in a naturally lit room you should consider how the light will affect your subject as the day draws on and the sun moves round. Also, light will change at different times of year. In the colder months the sun is low, the shadows cast are long, and the light takes on a glowing quality as the day develops. In the warmer months the opposite is true.

It is fairly straightforward to describe the changes of the seasons using colors—golden yellows and rust reds to portray the fall, for example—but a good exercise in sketching is to concentrate solely on the effects of

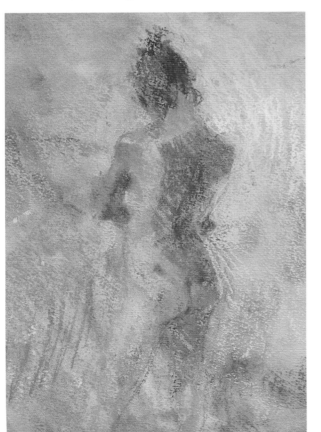

Left: nude
media: pastel and watercolor
Shadow tone need not always be gray and muted. This artist has pulled some of the colors used in the shadow on the figure's back and legs into the shading of the background, creating an overall sense of harmony and unity with the surroundings.

lighting on your subject. This way you will become attuned to subtle nuances or vibrant contrasts that lighting causes and be able to bring a sense of three-dimensional depth to your work.

Set up a small still life by a window that faces the sun, perhaps a chair draped with some colorful clothes. Leave the arrangement undisturbed for a whole day while you sketch it and the immediate floor and walls. Concentrate on tones of light and dark, adding texture and color if you like. Start one sketch in the early morning, then come back in the afternoon and do another, then return as dusk approaches and sketch again. By looking at your series of sketches you will observe how the changing lighting conditions affect the mood and atmosphere of your set-up.

Learning from the Masters

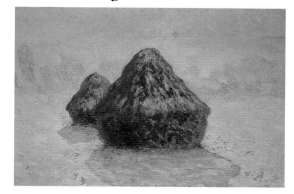

Claude Monet made an intriguing series of **oil** paintings of **haystacks** studying the effects of natural light at different times of the day. The subtle nuances of light and tone became the subject of the paintings —the haystacks are almost inconsequential.

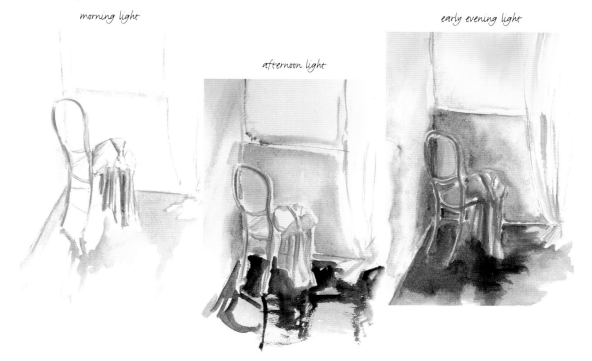

morning light

afternoon light

early evening light

Left: three chairs
media: watercolor
The first of these 15-minute sketches (far left) was completed in the fresh bright light of morning—note the vibrant colors. The second (middle) sketch was executed in the deeper afternoon light, when the colors become more somber. As dusk approaches and the third sketch is completed, the evening light casts a warm glow and the shadow by the chair fades.

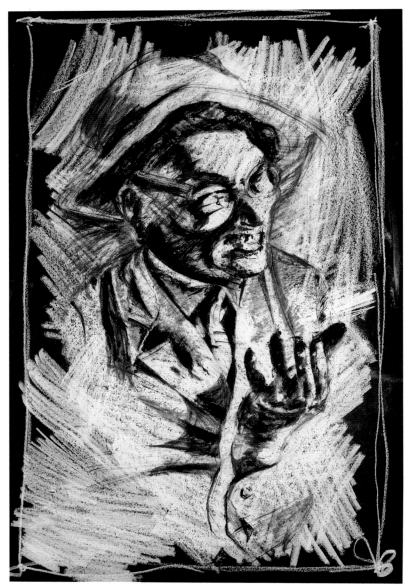

the artist has used a vigorous sketchy style of applying oil pastel to black card to complement the animated gestures of the figure

Artificial light

Working by artificial light, such as an electric bulb or by candlelight, will change the quality of light and tone you portray in your work. With artificial light you have the freedom to position the angle of your light source and can thereby experiment and exploit dramatic and unusual effects.

Stand in front of a mirror in a darkened room, shine a bright flashlight directly upward below your chin, move it to one side of your face, then hold it directly above your head, beamed downward. As you move the light source over your face notice how shadows lighten and darken and how different your face can appear under the changing light conditions. Position a member of the family or a friend directly beneath an electric light bulb so that shadows are cast downward. You will see how the eyes sink back into their sockets and the contours of the face are emphasized creating a chiseled, statuesque, even sinister appearance as the shape of the underlying bone structure emerges. Try placing a lamp on the floor to cast light upward onto your subject, creating a staged aspect recalling footlights used in old theaters. Sketch by candlelight or oil lamp and your subject will appear to emerge from the shadows. Some artists' work relies heavily on exploiting light and tonal effects to bring a sense of drama and atmosphere to their work. Try experimenting with your own ideas.

Left: man with hat
media: oil pastel
If you squint your eyes while looking at this image, the strong directional light almost reduces this portrait to an abstract design in black and white marks.

**Left: sketch after
Georges de la Tour's
*The Repentant Magdalene***
media: pencil
Deep shadows and glimmering
highlights evoke a sense of meditative
and spiritual calm. Georges de la Tour
excelled in rendering candlelight in
his work.

*to create a sense of glowing
light don't be afraid of
drawing most of the sketch
with rich dark tones as
these will give good
contrast to the highlights*

*illuminated
from above*

*illuminated
from below*

LIGHTING TECHNIQUES

In the above picture, the figure is illuminated from
the side by artificial light, but the contrast in light
and shadow would not be so different if sunlight
were flooding in from a single window. Of course,
you can always diffuse directional light, if it is too
harsh, by draping a canopy of fine cloth like muslin
in front of a window or an artificial light source.
Remember to keep drapes away from the
immediate vicinity of any naked bulbs, as they can
become extremely hot.

*illuminated
from the side*

Using color

It is useful to think of music when you bring color to your sketching work. The tones of color can be used to great expressive effect, and, like music, can readily evoke atmosphere and mood. You can be garish and loud with color or gentle and soothing. Whether the subject is a study of the human figure, a still life, or a landscape you can create a sense of serene tranquility, a passion and carnival brightness, or a dark and melancholy mood through the use of color alone. Despite all that has been written on color theory, the only real way of achieving effective results is to experiment with color and color mixes yourself; you will soon develop your own unique palette, finding there are color ranges and combinations that characterize your personal style of work.

 Colors have temperature and movement values. Cool neutral colors appear to recede; blue, for example, gives a sense of distance, while warm bright colors like red, come forward. Colors can bring a sense of warmth or coolness to your subject, and combinations can contrast successfully in one work. In your mind's eye think of a simple landscape scene. The sky is ice blue, the shadows a deep indigo, on the horizon sits a house, a bright

by mixing together the primaries—red, yellow, and blue—in couples, you will produce the secondary colors:—orange, green, and purple—diffused throughout this piece

Above: musical notes
media: watercolor
The sheer range of color combinations can be bewildering, yet good colorists rarely use more than eight colors on their palette..

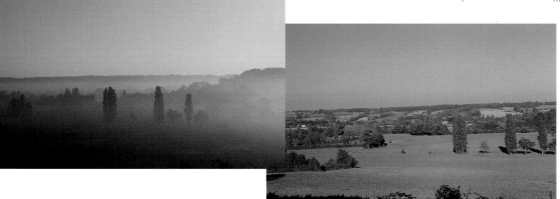

Left: the sun's influence
media: photographs
As these photographs show, the position of the sun can make a difference to the color of your subject matter. Catching the sun at a low angle at sunrise makes the colors subtle and pale; the added benefit of rising early is the mist which adds to the ethereal landscape. Later in the day, when the sun is high in the sky and has swung behind you, the colors and lines are strong and intense.

colors are often reflected when struck by sunlight; see how the red color of the sunshade is picked up on the hair of the figure sitting beneath

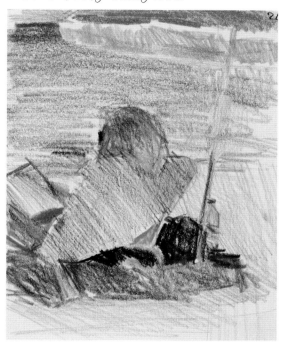

orange glows from the windows. In the cool landscape the house appears warm and inviting. Think again of the same scene. This time the house is white, the windows indigo, the landscape bathed a golden yellow. The house now appears to be a cool retreat. The same scene and subject matter interpreted in different color ways can dramatically alter our perception of it.

While you are working, stop to ask yourself about your use of color. Are you happy that the colors used simply reflect a true likeness of your subject? Could you make this work meditative or more active through the use of color? As an exercise, try bringing a definite sense of expression to your work through color, remembering that it can be loud and sing out to the viewer, or can whisper and still make for a more enduring and memorable work.

Above: on the beach
media: color pencil
A beach is a perfect place to sketch the effects of sun on color. As well as really accentuating color tones, sunlight requires corresponding areas of deep shadow to give emphasis to the contrasting effects of sunlight on the subject.

Left: seated figure
media: pastel and watercolor
The blue and pink in this colorful work bring a sense of warm and cool temperature values to the piece. The blue-toned shadow behind the figures give her credible three-dimensional depth.

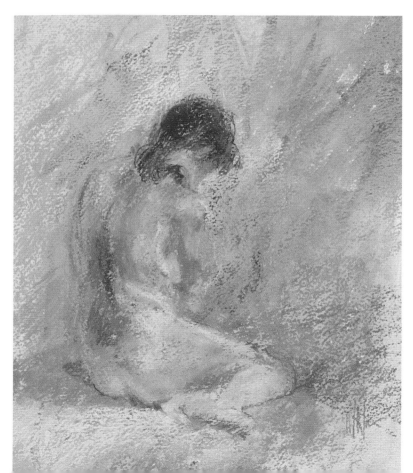

blue, green, ocher, and sienna—rather than darker shades—create shadow

A useful palette

cadmium yellow

cadmium red

alizarin crimson

viridian green

cobalt blue

ultramarine blue

ivory black

titanium white

raw umber

burnt sienna

yellow ocher

Payne's gray

Color mixing

When setting out to elicit an emotional response through color in your sketches, bear in mind that the appearance of many colors can be affected either positively or negatively by their placement next to or on top of each other. Also remember that sketching is your opportunity to experiment a little and see what works for you.

Take a sheet of mid-blue paper and fill a circle with yellow ocher mixed with a little lemon yellow to represent the sun. The painted sun will appear to glow and look quite sun-like, but if you take a sheet of white paper and do the same, your sun will not be convincing, but rather appear quite dull and flat in comparison.

Play with combining colors. Take, for example, an equal measure of yellow and red, or yellow with just a touch of white. Try contrasting colors of different temperature values and you can create discord and activity, as the eye flickers between cold and hot, then please the eye with harmonies of gentle color shifts.

You can mix together two or more paint colors to create new shades. Make a note of any successful color mixes you have found to use in future work. Deepen your colors with other dark colors, rather than black that will muddy your mix. You may have already discovered that mixing more than three colors can create a muddy mess; this is due to the manufacturer's binders mixed in with the pigments. Always bear in mind though, working with a limited palette can work just as well, if not better, than overloading your work with too many color combinations.

"break" a color with just a small trace of another to make a subtle color shift

Shades and tints

try adding white to mixes to make pale tints or darker colors to make deeper shades

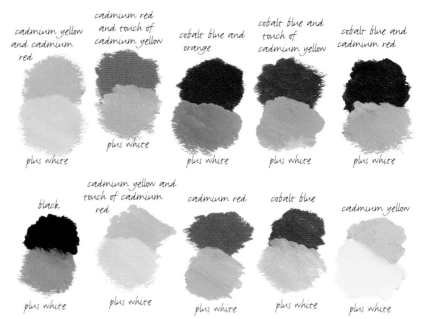

cadmium yellow and cadmium red

plus white

cadmium red and touch of cadmium yellow

plus white

cobalt blue and orange

plus white

cobalt blue and touch of cadmium yellow

plus white

cobalt blue and cadmium red

plus white

black

plus white

cadmium yellow and touch of cadmium red

plus white

cadmium red

plus white

cobalt blue

plus white

cadmium yellow

plus white

Earth colors and tints

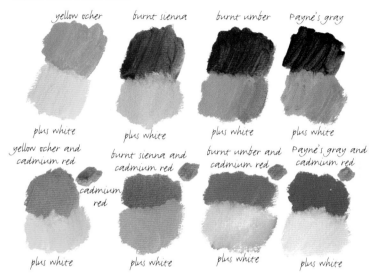

yellow ocher burnt sienna burnt umber Payne's gray

plus white plus white plus white plus white

yellow ocher and cadmium red burnt sienna and cadmium red burnt umber and cadmium red Payne's gray and cadmium red

cadmium red

plus white plus white plus white plus white

earth colors—the natural hues of the colors found in sand, wood, earth, for example—are particularly useful in painting subjects such as plants, flesh tones, and landscapes; shown above are earth colors mixed with white to make lighter tints, and mixed with red to create some different hues

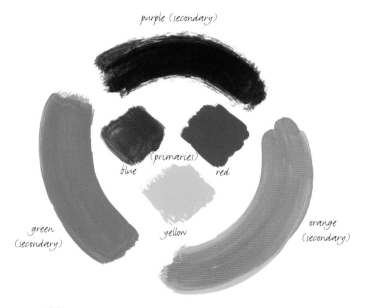

purple (secondary)

blue (primaries) red

green (secondary) yellow orange (secondary)

Primary and secondary colors

The primary colors are red, yellow, and blue. Secondary colors are mixes of two primary colors. Yellow and red make orange; yellow and blue make green; red and blue produce purple. Keep your mixes as pure as possible and clean your brush in clear water each time you make a new mix.

try mixing a little of a complementary color to its primary color to create the darker shades in the row to the right

Primary colors with their complementary color

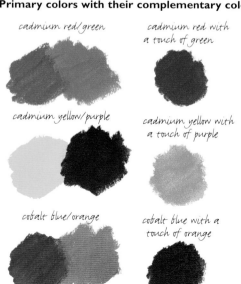

cadmium red/green cadmium red with a touch of green

cadmium yellow/purple cadmium yellow with a touch of purple

cobalt blue/orange cobalt blue with a touch of orange

MAKING A COLOR WHEEL

Try making a simple color wheel like the one shown here. Acrylic or gouache will work well for this exercise, but if using watercolors, try not to dilute the colors too much. Take the truest primary colors you can find in your color box; cadmium yellow, cadmium red, and cobalt blue would be perfect for this exercise. With a clean brush for each color, daub a blob of the three primaries next to each other in a circle as shown. Now mix the primaries together on your palette, two at a time to create all your secondary colors. Paint three arcs of the secondary color around the primaries it derived from, for example, paint an arc of purple above the blue and red daubs. You will now be able to see how the secondary color mixes relate to the primaries from which they derive. Look once more at your original daubs of primary colors. First take the red daub, and look at the arc of color directly opposite to it; this green is known as the "complementary" of red and each of the primary colors has a corresponding complementary colors. So, purple is the complementary color of yellow, as orange is of blue.

when a primary color appears next to its complementary colors, both colors appear more intense—use them carefully in your work, as they can create a dramatic effect in their juxtaposition

37

CHAPTER 2

Sketching

Taking hundreds of examples directly from the sketchbooks and notes of working artists, this section comprehensively demonstrates the practical use of the principles and materials covered in the first part of this book. showing a wealth of

your subject

different styles and methods, the author covers the areas of landscape
and natural history, still life and flowers, interiors, the figure,
portraits, and finally animals, revealing the media, techniques,
and aims behind these works of art.

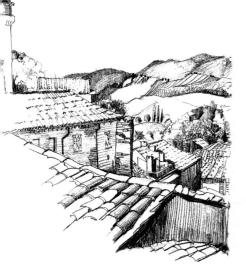

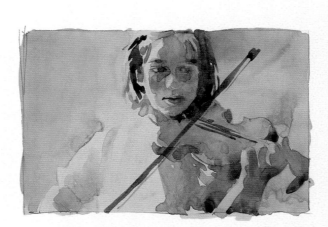

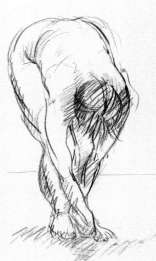

Landscapes are living entities and forever changing. They are animated by transitory phenomena like the weather, the seasons, sunlight and shadows, reflections, cloud formations, and the comings and goings of animals, people, and traffic.

The key to working outside is to make life as easy as possible for yourself. Before you set out, consider what you want to achieve in a day and take a little time to get

Right: city landscape
media: pencil
This wonderfully free sketch gives the impression that the artist hasn't taken his hand off the paper while sketching. In the words of the artist Paul Klee, "take the line for a walk."

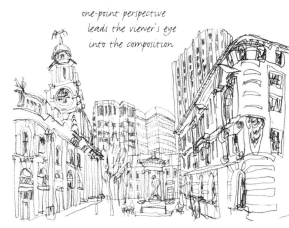

one-point perspective leads the viewer's eye into the composition

sketching freehand can keep a study of the city landscape from becoming too linear and rigid

Landscapes and Natural History

yourself organized. You will really benefit from traveling light with ready-to-use materials, so choose those that you feel confident with and with which you can work with a degree of haste if necessary.

Check the weather forecast before you leave and be prepared for a change in conditions. The day might start off looking particularly good for concentrating on lighting effects, but if clouds roll in you'll find the bright contrasts in colors and tones you were working with will evaporate before your eyes. If the weather conditions do change and spoil your original plan, have a back-up plan. You could turn your attention to studying details, like textures from nature or passers-by. Such studies will improve your sketching and can be incorporated into further pieces.

Whatever situations you encounter, any concentrated sketching of a landscape subject will accustom your eye to its endless fluctuations of color, light, and movement. Mastering these effects will breathe life into your work and provide you with a rich source of material.

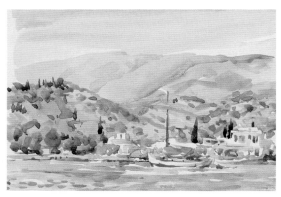

Above: sailboat in harbor
media: watercolor
It is useful to take a small selection of media out with you. Chalk pastels and watercolor can wonderfully convey color and light effects, while ink pen and pencil are ideal for structure and fine details.

here, watercolor conveys the moody atmosphere of the sparkling skies and water

diluted ink is applied with a fairly dry brush to describe the foliage

the trunk and branches are depicted in strong dark accents

Above: tree in sunlight
media: ink wash
Bright sunlight provides perfect conditions to work on trees in leaf, transforming the trunk and branches into dark shadows, and touching the dark, bushy foliage with bright highlights.

40

Below: barn window
media: pencil
Using mainly fine vertical line work, the texture and lighting effect of sunlight on stone is effectively portrayed in this study of a derelict building.

Right: rural landscape
media: pen and ink
Make your sketchbook a travel log of journeys and discoveries. Using pen and ink can add a wonderful feeling of spontaneity to a fixed scene.

dense hatching gives depth to the interior and adds contrast to the whole sketch

the ease with which the lively doodle-like marks have been drawn belies the skill and confidence needed

strong horizontal white breakers are created by keeping the paper white

the artist has cleverly captured the transition from yellow sand to shallow green water to, finally, deeper blue waters

Right: seascape
media: watercolor
The regularity with which waves repeatedly hit the shoreline enables the artist to make a concentrated study of form in motion.

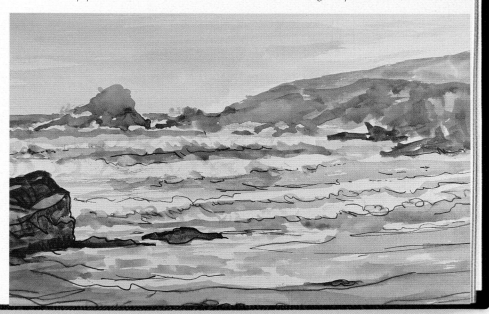

the composition gives the impression that we are at the water's edge

Sketching around town

Although the urban landscape might appear a seemingly limitless pot of perspective conundrums, it is, first and foremost, a subject brimming with visual excitement, waiting to be exploited by the artist. Like any landscape, the metropolis has its own cycles and transforms itself at different times of the day. As business closes down for the day and rush hour draws to a close, so a bustling district can become eerily empty, almost desolate. Yet in another area, back streets and quiet squares light up and transform into a magical wonderland of theaters, gaudy window displays, and lively bars bathed in lurid colors and deep shadows.

As well as bright advertising billboards and signs, there can be interesting details right beneath your feet; metal gratings, road markings, even debris and litter can provide a source of interesting colors and textures. As a contrast, find a high or distant vantage point, such as a view from the top floor of a department store, or from a hilltop overlooking the city. By day and night the urban landscape takes on a quietly awesome perspective above the commotion of traffic and people.

Sketching in the city can be challenging and a camera is always a useful tool to have at hand. Photographs in this situation can certainly support your sketch work. For instance, you may find a gem of a subject to sketch but it is just not practical, with congested sidewalks and traffic to contend with, to begin sketching on the spot. Sketching on location tends to attract the natural curiosity of onlookers, adding to the interference

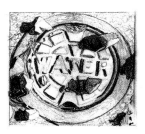

embossed and engraved letters and symbols provide texture and interest

Above: manhole covers
media: pencil
Feeling overwhelmed by the confusion and complexity of a vast urban landscape? Remember it can offer you a rich source of visual details and features on a small scale too.

Left: modern architecture
media: pencil
High-tech buildings can appear intimidating in their complexity. This artist, however, chose an informal "doodle" style to sketch this imposing office block and, as a result, has more character than a traditional architectural drawing.

Right: cycling over a bridge
media: mixed media
This brief sketch is full of structures, including bicycles and people, that conform to no rules except the artist's own idiosyncratic style. Such a view of a foreign city can be a reflection of a tourist's first impressions.

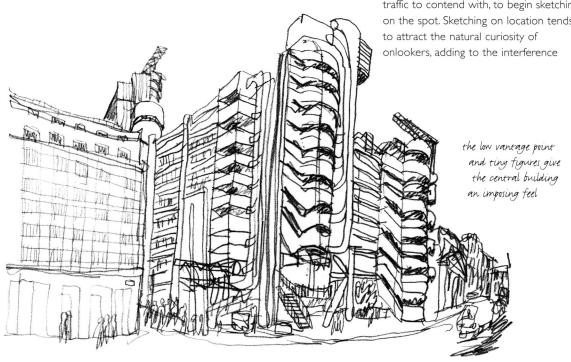

the low vantage point and tiny figures give the central building an imposing feel

the artist has used pencil, pen, and watercolor to convey a different culture and atmosphere than that of her home town

the scratchy lines give an attractive, ironic quirkiness to the drawing, as if the artist was more interested in the overall pattern of the scene than in reality

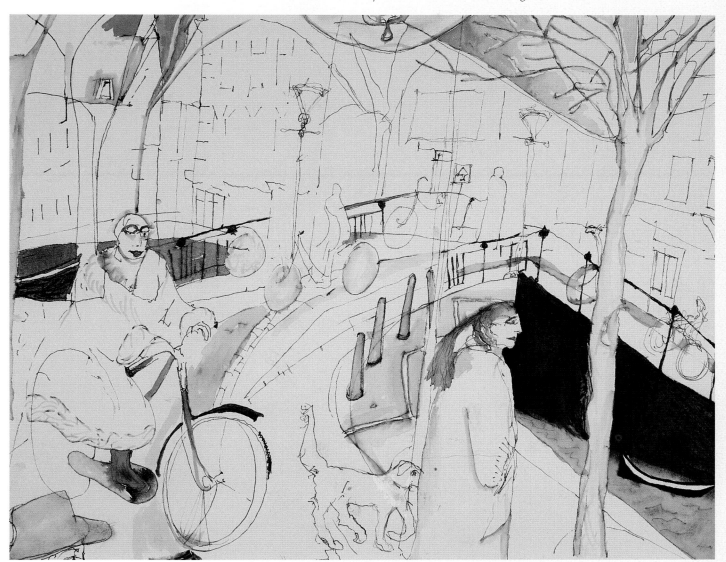

of your concentration. Use your camera to shoot a series of photographs to refer back to while you sketch in the privacy of your home.

Analyzing perspective

The city provides a wealth of exciting visual material to work from but at the same time presents the artist with a challenge: to capture the mood of an urban landscape without being deterred by visual clutter and confusion. To do this you can use artistic license to be selective, reducing your subject to its essentials.

A good exercise with which to start is to draw sketches from a photograph of an urban landscape—a photograph will have transformed the landscape into two dimensions already. Try taking a camera into the city and finding your own subject matter. Look through the lens as you would a viewfinder. Begin by concentrating on regular solid forms and structures. If you are working on a bright day, the sun will create strong tonal contrasts and directional light that will sharpen your image and add depth to your work. Take shots of buildings and streets from different angles and perspectives.

Using a photograph as a tool

After developing the photographs, lay some tracing paper over them and pencil in the position of roads, bridges, and buildings and their main architectural features—windows, doors, roofs—and then shade in any shadows they cast. Don't get bogged down with

Top right: looking down a city street
media: pencil
The strong directional lines of perspective take the eye straight down this street scene. Although it is crammed with detail, it successfully avoids looking cluttered.

Right: Mediterranean townscape
media: ink
If working from a photograph, simplify a scene of crowded buildings and rooftops by making a brief tracing over the top. Include any areas of light and tone to give a three-dimensional effect.

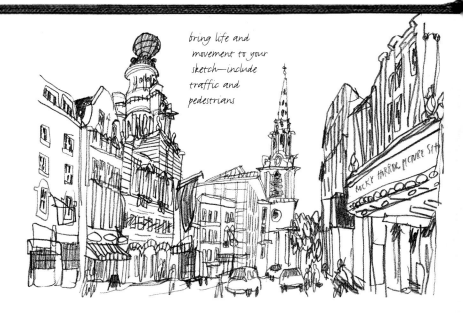

bring life and movement to your sketch—include traffic and pedestrians

to give dimension to this scene, imagine the buildings as randomly stacked boxes of varying shapes

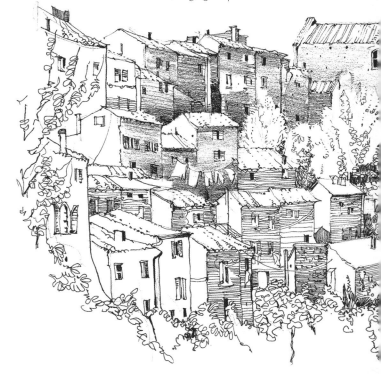

too much detail at this stage. When you remove your tracings you can see for yourself how your urban scene is reduced to a scaffold of outlines, simple shapes, and areas of light and tone. You will notice how lines and forms create perspective, directing the eye this way and that within the picture. Now move a viewfinder over your tracings to find a composition you would like to take further. When you have found compositions that seem promising, refer back to the original photographs.

Draw a line around or cut out these sections of the photograph to use as source material. You might want to return to the place where you took the photograph and work from life. This will help to give your sketch a sense of vitality and immediacy.

With practice and experience you can take your viewfinder to your outdoor subject, and work directly from sight. But this initial exercise will help you organize any complex subject matter that is visually exciting.

Below: washing day
media: pencil
The carefree yet cluttered nature of small Mediterranean towns is part of their charm, but reduce architecture to its bare essentials to avoid a muddle.

then concentrate on seeing and drawing the strong contrasts of light and shadow falling on walls

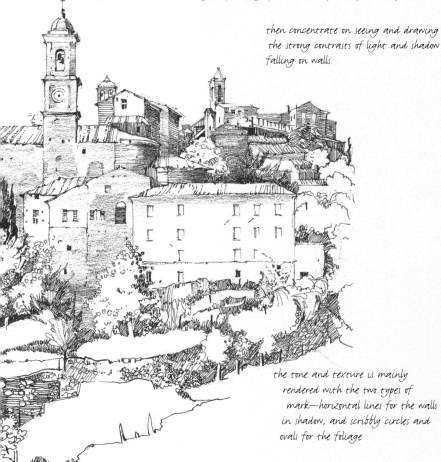

the tone and texture is mainly rendered with the two types of mark—horizontal lines for the walls in shadow, and scribbly circles and ovals for the foliage

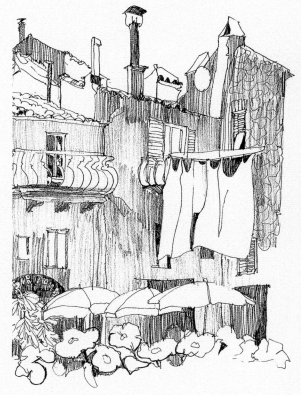

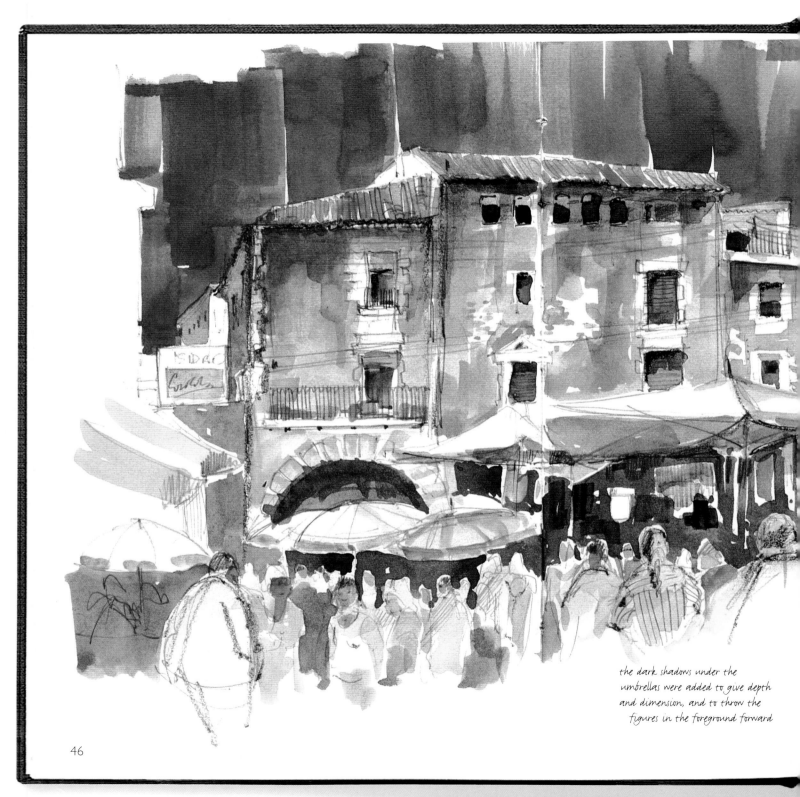

the dark shadows under the
umbrellas were added to give depth
and dimension, and to throw the
figures in the foreground forward

broad, flat-edged brushstrokes were used to block in the sky quickly

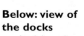

market places, with their bustle of movement and color, are great places to sketch

Right: taking a break
media: pencil

The artist was interested in the study of structure when she came to sketch this side street in Venice. Even the depiction of the two figures relaxing in this café scene sit happily within the architecture of their surroundings.

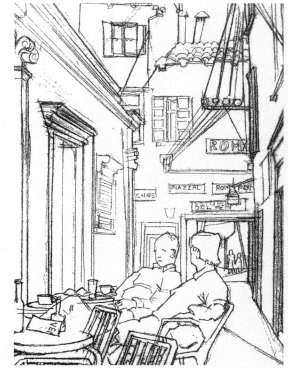

depth is achieved in the steep sloping angles of the building on the left and the two tiny figures in the distance

Below: view of the docks
media: ink and wash

By sketching the "hard edged" structures of heavy industry from this perspective over water, this artist has brought an overall loose and softening effect to his subject with reflections.

this artist has handled his subject with a sensitive delicacy in both line and tone

Left: market scene
media: watercolor

The mixture of media works well here; the brief sketchiness of the underlying drawing in pencil brings movement to the scene while the contrasting dark and light washes of watercolor bathe the scene in warm sunlight and cool shadow.

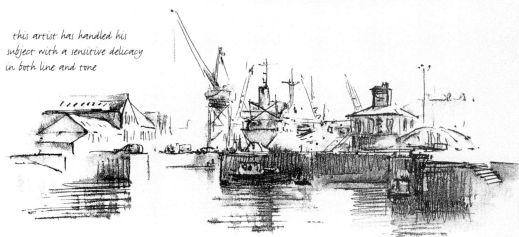

47

In the great outdoors

In a vast rural landscape, a viewfinder is a useful tool for selecting a location and organizing a composition. Look through it as you would a camera and move around until you find an interesting scene. Look for something in the landscape that captures your attention and could become a focal point in your work, for example a row of trees, a figure, or a lake. Move your viewfinder around your focal point, making thumbnail sketches as you go, until you think you have a satisfactory composition.

If you feel the composition needs something else to make it work, you can always use artistic license by adding objects from studies you have made elsewhere. If you use artistic license, pay particular attention to the direction of lighting in your landscape because the lighting will need to fall and cast shadows in exactly the same way. Of course, you don't need a focal point at all; a rural landscape is a rich source of color and light effects and an ideal subject in which to explore space and distance.

Exploring space and distance

To create a feeling of space in your landscape, think of two directions: one leading into your picture, taking your eye toward the horizon; the other leading out and beyond the picture area. Look for natural lines in the landscape that will emphasize the sense of direction. You could take, for example, furrows in mud or fields, fences, paths, rows of hedges, trees or crops, or telephone poles to lead the eye into the picture or off to one side. These leading lines can create the illusion of three-dimensional depth. In a skyscape a sense of depth can be suggested by overlapping and stacking clouds. Working from the smallest cloud formations on the horizon to the largest in the foreground you can create an impression of great expansiveness as the sky and clouds will appear to move out toward the viewer and beyond the picture area.

You can enhance the sense of depth in your work still further by using aerial perspective. This is the phenomenon where the landscape appears to become paler as it recedes into the distance and we view

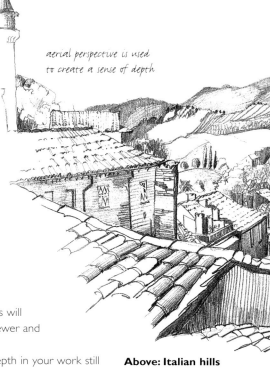

aerial perspective is used to create a sense of depth

Above: Italian hills
media: pencil
The eye is drawn over the rooftops to the trees and undulating hills beyond.

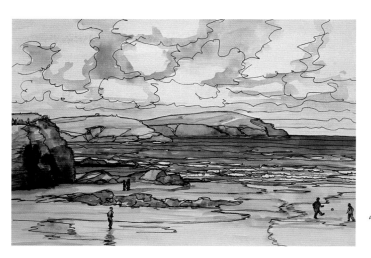

Right: a breezy day at the beach
media: mixed media
This sketch successfully combines several devices to emphasize a sense of space and distance. The clouds stack up in the sky, the cliff heads overlap, and the figures help us to relate the landscape to a human scale.

the sea, clouds, and rocks are defined with ink lines, and the watercolor adds atmosphere

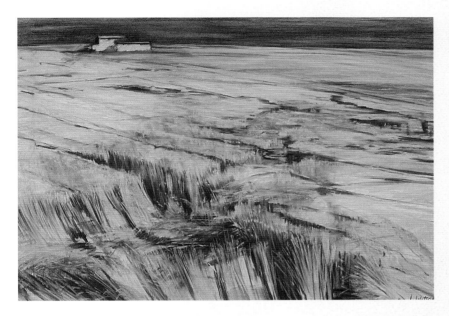

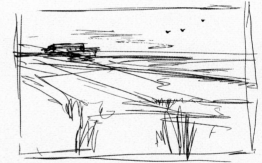

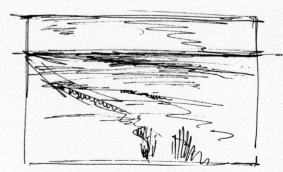

the eye is led one way by the furrows of the field and then has to skip over to the other side to the house

the furrows lead the eye to the far beyond and out of the picture, giving a feeling of expansive distance

with no house at all, the eye dwells on the field alone, conjuring up a desolate feel

Above: The Field
media: chalk pastel
The artist made a few brief thumbnail sketches in pencil before deciding on her final arrangement for this drawing in chalk pastel. Although the composition is simple, each small sketch gives quite a different impression of the scene.

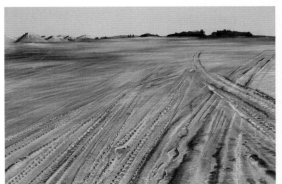

Above: Exodus
media: chalk pastel
The bleak feel of *The Field* inspired the artist to follow the work up with this pastel piece exploiting the impression of emptiness.

clever hatching and line work give an impression of branches leaning over—and reflected in a pond

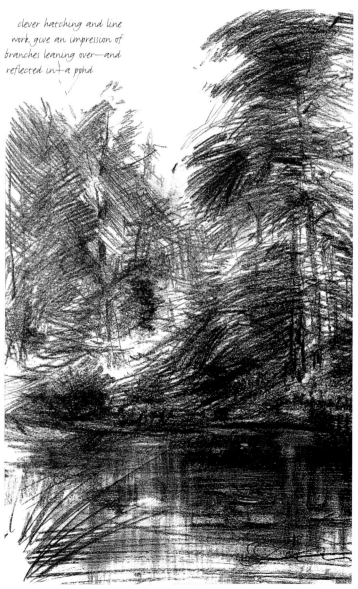

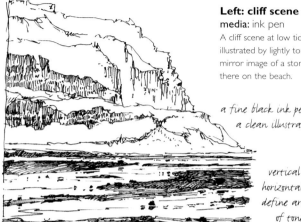

Left: cliff scene
media: ink pen
A cliff scene at low tide is simply illustrated by lightly touching in a mirror image of a stone here and there on the beach.

a fine black ink pen creates a clean illustrative style

vertical and horizontal lines define areas of tone

Left: reflections
media: pencil
The reflections of trees by the water's edge bring a dark moodiness to the scene. Notice how there are two directions of lines reflected in the water: vertically, suggesting the reflections of the trees; and horizontally, with the ripples defining the surface of the lake.

Right: ripples
media: pastel
A breeze on water can produce a wonderful ripple effect, giving life to the image.

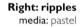

Tip: *Try sketching a tree in ink or watercolor. While the sketch is still wet, fold your paper so that the image prints upside down under the original. Sketch in a line between the two images. Note how the branches mirror each other as they would in a reflection.*

it through layers of atmosphere. Partially close your eyes as you look toward the horizon and this will become more apparent.

Reflections in water

Reflections in water can make an excellent focal point in a rural landscape, but some conditions make water a challenging subject to sketch. Whether it is a lake, pond, river, or the ocean, water will reflect the sky above and any landscape around it. Water is continuously moving— anything more than a ripple on the surface will break up your reflected image and if it is a bright, sunny day then the water might also reflect sheets of light.

A pond is a good place to start, since the water here will be relatively still. Use the trick of squinting your eyes to reduce your image to tones of light, dark, and color and concentrate on the overall impression rather than details. Look out for strong vertical lines in your landscape, such as tree trunks, buildings, hills, or mountains—or, in larger water areas, such as the sea or rivers, masts and sails of boats. Sketching verticals in the water will really help to achieve the mirroring effect of reflection on water.

Cloudy skies

When we think of clouds we often conjure up the image of something round, white, and fluffy. If this were true, clouds wouldn't bring much to a landscape subject. However, by stacking clouds one on top of another you can bring a great sense of depth to your landscape. Clouds can also charge your work with atmosphere and movement. Dark layers of cloud cover can bring a strong sense of foreboding to a scene or they can illustrate the raging storm itself in tumultuous squalls. The wispiest streaks on a summer's day can create a clear sense of direction or, in contrast, they can stand as imposing sculptural shapes in their own right.

Left: view from an airplane window
media: ink pen
This is a world away from the amorphous vaporous clouds we might be familiar with in paintings.

hatching in pen and ink —combined with chalk— adds bulk and texture to the clouds

Learning from the Masters

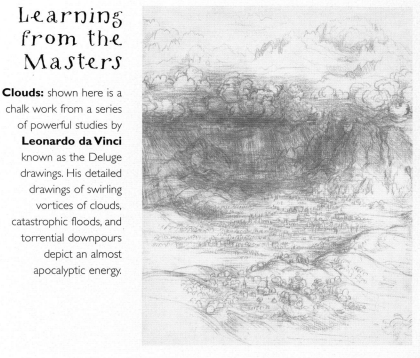

Clouds: shown here is a chalk work from a series of powerful studies by **Leonardo da Vinci** known as the Deluge drawings. His detailed drawings of swirling vortices of clouds, catastrophic floods, and torrential downpours depict an almost apocalyptic energy.

51

Inspired by nature

Looking closely at natural forms, and then using your sketchbook to record what you see, can be a rewarding challenge. Not only does it give experience in expressing form, texture, pattern, and line in different media, but it also leads to a greater understanding and appreciation of the natural world.

Search out your sources

Searching for source material is part of the excitement. You could start with a fruit and vegetable stall in the market, where you will find a vast assortment of colors, textures, and forms: pineapples with their prickly skins; peppers with their contorted shapes; bunches of grapes; and pomegranates with their jewel-like seeds. At the fish stall you may be attracted by the displays of fresh fish, shellfish, mussels, prawns, crabs, and lobsters. In your garden and along a country path there will be more to look out for. In spring, buds will be bursting into leaf, a tree may be coming into blossom.

In summer, you'll see grasses, ripening corn, sprays of

Far left: sheep's skull
media: mixed media
The anatomical structure of the skull is frequently used as a source from which to study. Their cavernous form has intrigued generations of artists. This sheep skull has been sketched with pencil and gouache on a scrap of packaging paper.

Below: shells
media: photograph
You will frequently find the inside of a shell reveals different colors and textures to the outside. Try making more than one study of the same specimen, turning it over to view it from a different angle.

the brown tone of the paper becomes the mid tone of the study to which white highlights and dark shadows are added

shells can offer an enormous range of forms and patterns

Tip: *Stores specializing in the sale of shells should be able to tell you their origin. While many are collected empty of their inhabitant, don't purchase them if they have been killed for trade.*

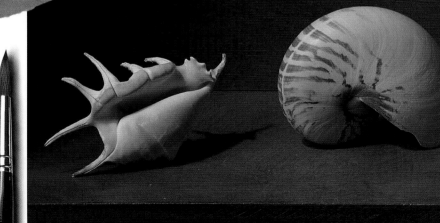

leaves, and insects like butterflies, bees, and beetles. In the fall, you will encounter ripening fruits, nuts, hips, berries, seed heads and falling leaves. In winter, look around for old, gnarled tree roots, pieces of bark, spiky evergreens, pine cones, and plant rhizomes waiting to be divided and replanted.

Going further afield, a beach will provide another rich source of treasure objects such as seaweed, fossils, pebbles, driftwood, and seashells of all shapes, sizes, and colors. If you happen upon rock pools you may find beautiful tiny gardens of delicate wafting seaweed and reflections. You might, of course, consider the sea itself, and try to capture its changing moods, whether it is the energy of the waves crashing on the shore or the lightly ruffled surface of a rock pool.

Visit local museums and park nature centers that usually have a section devoted to natural history and geology. Although you will not be able to touch the

Below: cameo studies
media: ink pen
These two cameo studies of the trunk and foliage of a palm tree describe in detail the coarse huskiness of the trunk and its interwoven texture. The long palm fronds softly droop in contrast.

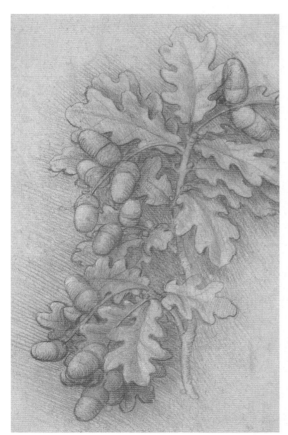

Learning from the Masters

Acorns: Working in the late fifteenth and early sixteenth century, **Leonardo da Vinci** filled hundreds of sketchbooks with botanical drawings. His specimens are so closely observed it is as if he was trying to reveal the very mysteries of the natural world within his intricate studies. Here, a spray of humble acorns drawn in red chalk is touched with white highlights.

by leaving the paper blank, the artist creates highlights on the palm tree trunk

a fine ink pen is the perfect medium for detailed work

the vertical lines create a pattern as well as creating a sense of the heavy, lush leaves

exhibits, you may well find unusual and exotic subjects to work from, such as animal skulls and skeletons and geological specimens.

Translating your finds

Once you have chosen your subject, you need to look at it in good light. If possible, examine your piece against a folded sheet of stiff white card or paper propped one half up against a box or books on the work table. If your subject is light colored, you could place it on a darker toned paper to delineate the edges of your subject. By creating such a background you will be able to focus on your subject and cut out distractions. Choose the angle from which you wish to draw and, if necessary, fix your subject in position. A magnifying lens can be very useful when studying small subjects and details.

When examining your subject, consider the qualities it has that give it its unique character: for example, a fish is wet and slippery; a coconut husk is coarse and hairy; a flower petal is soft and moist. Then decide on the most appropriate medium to convey these characteristics. This will depend on whether you are planning a detailed study, in which case fine pencils and pens will be a good choice, or whether you are working from large forms that require a broader medium like charcoal, pastels, or watercolor.

texture and pattern are paramount

Left and right: cone and nutshell
media: pencil
Enjoy the intricate detail and sculptural shapes found in cones, nuts, and seed heads.

a clever use of hatched shading defines much of the delicacy of the form of the nest

Have a range of media to hand so that you can experiment with different marks and effects.

Look closely at the way the light falls across the subject and the way it casts shadows on the surface where it lies. These shadows help to define the forms. Use the trick of screwing up your eyes to focus on the tonal contrasts of your subject. The contrasts can be gradual, as they would be on an egg, or abrupt and sharp, as they would be on the surface of a pepper.

Make a practice of giving each subject one page to itself. You will then have room to extend your studies later, homing in on details, different textures and colors, or making notes for your visual diary. Or you may wish to make a simple linear sketch of the place where you found your natural object.

Try grouping different objects together to create a variety of textures and forms. You may decide to work on a theme, like a river or a field, or take just one object to study in detail. Whatever your subject, you will find that homing in on a small area with a magnifying lens will reveal a wonderful world of abstract shapes and designs.

some leaves are left blank, while the detail is shown on others—this, plus the dark hatching of the shadows, gives depth

Above and below: bird's nest
media: pencil
The artist has focused on the detail of the eggs, feather, leaves, and dense tangle of twigs and mosses, rather than the structure of the nest itself.

light, tone, and delicate lines define a feather

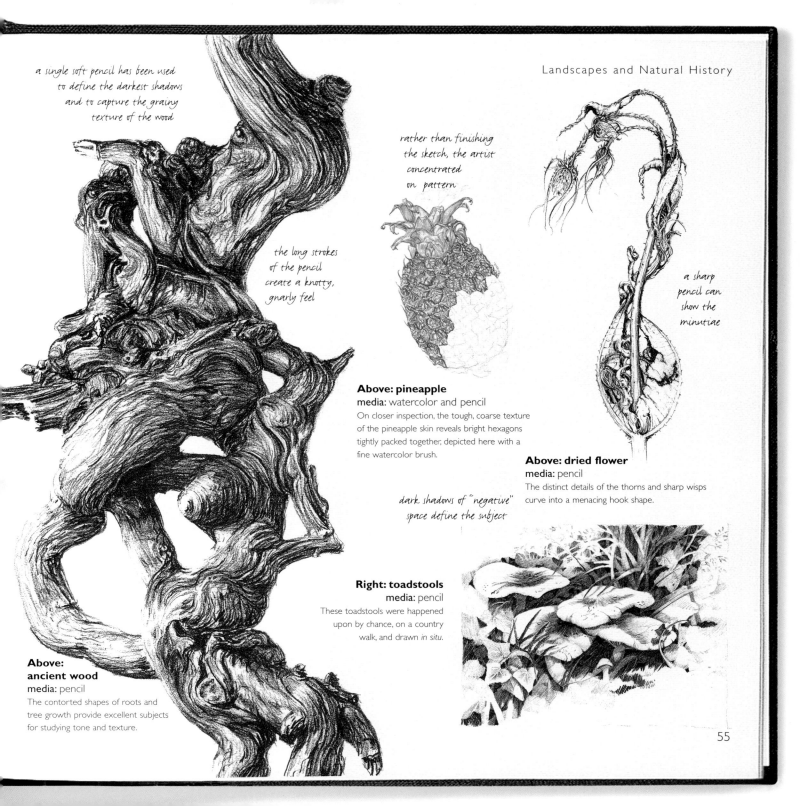

a single soft pencil has been used to define the darkest shadows and to capture the grainy texture of the wood

rather than finishing the sketch, the artist concentrated on pattern

the long strokes of the pencil create a knotty, gnarly feel

a sharp pencil can show the minutiae

Above: pineapple
media: watercolor and pencil

On closer inspection, the tough, coarse texture of the pineapple skin reveals bright hexagons tightly packed together, depicted here with a fine watercolor brush.

Above: dried flower
media: pencil

The distinct details of the thorns and sharp wisps curve into a menacing hook shape.

dark shadows of "negative" space define the subject

Right: toadstools
media: pencil

These toadstools were happened upon by chance, on a country walk, and drawn in situ.

Above: ancient wood
media: pencil

The contorted shapes of roots and tree growth provide excellent subjects for studying tone and texture.

a variegated watercolor wash of sap green, lemon yellow, cadmium yellow, and hookers green light was added

Right: the old and the new

media: pen and ink with watercolor wash

The artist was fascinated by the complex pattern of the skeleton branches, still visible through the haze of early spring leaves. The sketch took about three hours to complete—there is no short cut to sketching bare branches such as these—but good observation and a love of intricate drawing pay off in the end.

Close observation took in details such as the branches that cross over each other, and those that grow backward and downward, all of which add realism to the drawing. Despite their complex nature, the three basic tree skeletons are emphasized through tonal hatching, giving a good compositional balance to the sketch. A simple watercolor wash was added to convey the bright green of the new leaf shoots.

new leaves—painted as blobs of the variegated color mixture—were dotted at the twiggy end of the branches

hatching gives texture, tone, and depth to the sketch and the direction of the marks made implies both perspective and direction of growth of the branches

The words "still" and "life" seem contradictory. They conjure up in the mind an image of a group of static, lifeless, everyday objects arranged on a piece of crumpled fabric. Yet, some of the greatest masterpieces of the past, and indeed of the twentieth century, are still life groups, which consist of objects no more exciting than a collection of fruit, wine bottles, and lengths of fabric.

It is tempting to focus one's whole attention on just the objects exclusively, but then we would describe them as studies. In a still life it is more important to achieve an overall balanced composition combining inter-relationships of shapes, tones, and, if we are using it, color also. Keep in mind the spaces between the objects

define form by sketching the space around it; this gives the work an indefinite soft edge that works well in tonal studies

Still Life and flowers

complex lines and angles sketched with a sharp pencil

Above: garden flowers
media: pencil
Notice how the white areas of this sketch have been created by shading the negative areas, the spaces between the flowers, and the shadows in the window panes.

Left: bicycle and stool
media: pencil
A bicycle is a complicated structure, made even more so in this sketch as the front wheel is foreshortened.

are as important as the objects themselves. When you start collecting objects for your own still life arrangements, look out for things with interesting forms and textures, natural or man-made.

When you begin to set up a still life, think about the relationships of shape, tone, and space. Consider the scene's background as an integral part of the composition; don't allow your objects to become studies appearing to float in space. You need only look at the work of accomplished artists such as Cézanne and Morandi to find some of the numerous ways the still life set-up has been tackled. Make some sketches from their work to accustom your eye to the relationships that create a successful composition. You will discover that there is no one solution. The excitement comes from finding your own answers.

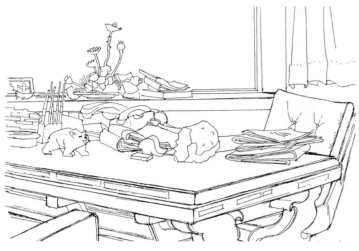

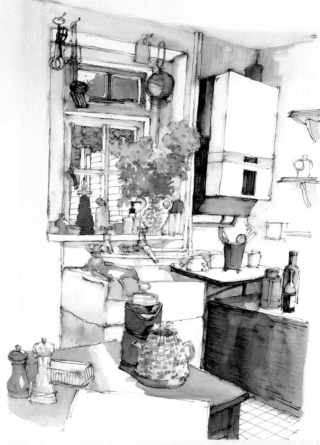

Above: desktop
media: ink pen
By excluding texture, tone, and color, the artist is almost restoring order to a cluttered desk.

the unfaltering fine pen line is used in an illustrative style

Right: kitchen still life
media: ink and watercolor
Pen and ink is used to plan the composition, defining its structure and the shapes of the objects.

exaggerated features and comical expressions can be fun to sketch

watercolor is used to add pattern and texture, which animate the scene

Left: toys
media: pencil
Soft toys collapsed and slumped against one another can present a variety of textures and patterns.

Still life

the bottles were painted white so the artist could focus on the play of light and shadow

When first setting up a still life arrangement, consider your lighting. If you are planning a quick study, try placing the arrangement near a window to make use of natural light, watching how it behaves at different times of the day. If you are thinking of doing a longer study, choose an area where the light will not change. You could work under artificial light if you want controlled conditions and the chance to create exciting light effects. Try angling a lamp on your subject for dramatic contrasts and strong, directional light effects.

To experiment with shape and tone, spray or paint some white matte paint on a group of four bottles with different shapes. The sort of paint used to spray cars is ideal for this (but take care to wear a mask over your nose and mouth). Put the bottles in front of a sheet of white card and stand them, some overlapping, on a white surface, such as a tabletop covered with another sheet of paper. In your sketch, establish the horizon fairly quickly. This will differentiate the vertical and horizontal areas and help to create the stage. The aim is then to focus on shapes and their relationships with one another and to evaluate light and tone without being distracted by texture and color. Look at the spaces between the bottles and the shadows they cast on the background and on the surface of the table.

You can also experiment with color. Find some everyday objects, but don't be too ambitious by trying to include too many: two or three apples on a plate, perhaps with one cut in half, can produce an interesting composition of sculptural, curved shapes. Place your objects randomly together to start with. Scatter them, then cluster them, or make a small group with one or two objects placed apart from it. Home in for close-ups, maybe crop some of the objects with the frame of your

Above: thumbnail sketches of bottles
media: pencil
An experiment in composition, light, and tone. By moving or removing the bottles, the focus of attention changes.

Below: vases
media: charcoal
Try moving your viewfinder over your image, shifting the focus from the objects themselves to the light and shade falling behind them.

Learning from the Masters

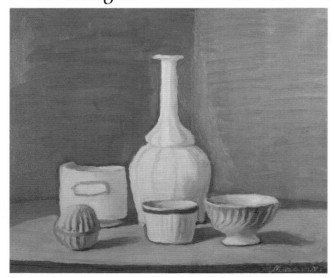

Everyday objects such as cups, jugs, and bottles—carefully grouped on tables or shelves—became the subject matter that fascinated **Giorgio Morandi** for almost 30 years. The lighting of his subjects oscillate between harsh and dramatic in some, to opaque and misty in others. His colors could be strong and deep, or pale and ethereal, and sometimes even a combination.

there are no outlines to the vessels; the three-dimensional forms seem to be sculpted entirely in light and shade

a quick charcoal sketch that was probably completed in the time it took for the kettle to boil

Left: on safari
media: charcoal
The artist made this sketch of her simple breakfast arrangements while traveling in Africa.

picture. You could even try suspending some objects on string or devise ways to create different levels. Keep using your viewfinder to look at the arrangements and to make thumbnail sketches from the different viewpoints. When you are satisfied that you have achieved a composition with a good relationship of shapes and tones, sketch it in pencil or work directly in color using colored pencils, oil or chalk pastels, or watercolors, or try a combination.

As you gain confidence you can consider experimenting with a wider range of objects, perhaps introducing ones with more complex shapes and ones that provide an opportunity to explore patterns.

cross-hatch with a ballpoint pen to describe light and tone

orange, the complementary color of blue, lets the apples "sing out" against the blue shadows

Above: three apples
media: watercolor
This small watercolor study shows how the simplest of subjects can be transformed into a work of jewel-like quality through the sensitive use of light and color.

Below: family shoes
media: pencil
Whether worn, dainty, rugged, or sporty, shoes convey so much character, they make excellent still life subjects.

Left: deck chair and hat
media: ballpoint pen
The chair may just have been vacated. The casual set up could have caught the artist's eye and she started the sketch without rearranging anything.

a simple pencil has captured the varied textures of leather, rubber, cloth, and wood

when viewed front on or slightly turned to one side, shoes make a good topic to practice foreshortened perspective

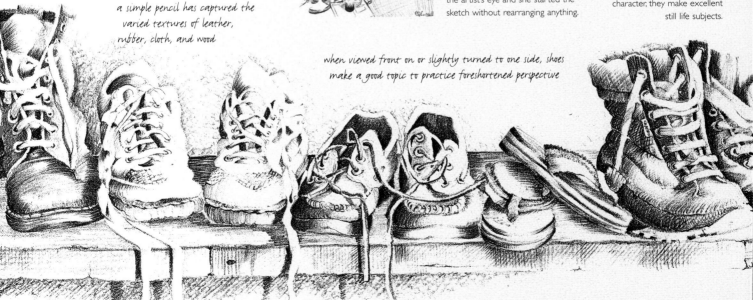

flowers and foliage

Perhaps it is their fragile beauty, the delicacy of their structure, and the rich variety of their colors that makes us want to preserve the ephemeral beauty of flowers in a picture.

When selecting and arranging your flowers, don't be too ambitious and get carried away by the sight of a lavish display of complex shapes, colors, and textures. Choose flowers with strong shapes. Tulips make good subjects, particularly when their stems begin to lose their stiffness and they start to bend over; the opening petals add interest, particularly in the large variegated varieties. Consider irises, peonies, and anemones, together with lilies, poppies, and sunflowers—they all have bold shapes and colors that you don't need a florist's skill to arrange. Nor do you need to have a great variety; in fact you only need a few to make a stunning arrangement.

Sketching simple arrangements or just a single flower alone will help you focus your attention on the beauty of the plant's integral structure and color. When mixing species, try to keep together those flowers that complement one another, so that garden flowers are grouped in the same arrangement while wild flowers and more sophisticated sculptural species, like lilies, are kept on their own. Two or three pots of pansies or polyanthus (primroses) make very good subjects to begin with. They have brilliant colors, a flattish structure, and strong, clearly defined shapes. They are easily available and also long-lasting. Put your pots against a plain background; pin a single piece of color paper onto a drawing board and prop it against a box or pile of books on a table covered with a plain cloth or one with a border that complements the colors of the flowers.

Right: bright blooms
media: acrylic
The artist has concentrated on the play of light and color in this sketch. With its free washes of pure color, it could be developed into a dazzling textile design.

break the frame with your study here and there, giving it room to breathe

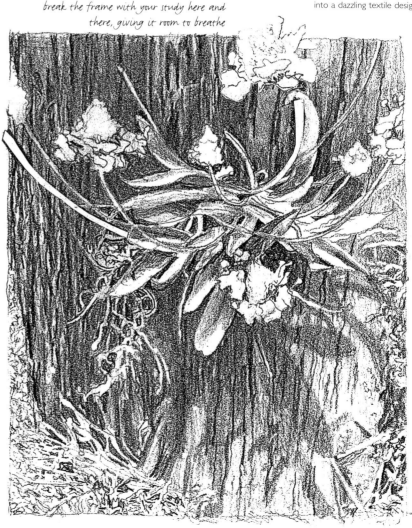

Right: flower and bark
media: pencil
A study of flowers is transformed into a small cameo by including a backdrop of textured bark and enclosing it within a frame to make an interesting composition.

62

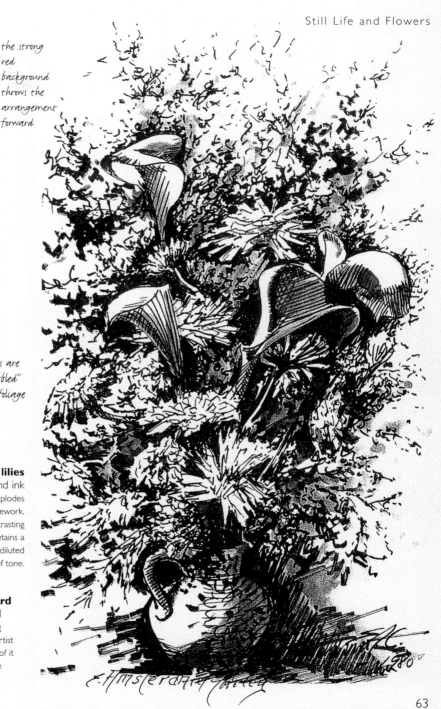

the strong red background throws the arrangement forward

When you have gained confidence, you might try arranging flowers in more elaborate displays against different backgrounds that include patterns and colors to achieve a highly decorative look.

Alternatively, why not make a setting for your arrangement? You could create a potting shed background by putting the displays on a plank of wood in front of a piece of sacking or add an old watering can, some flowerpots, or gardening tools. A windowsill will also make a good place to stand a flower arrangement; it will not only look at home there, but the window frame itself can help to structure your composition.

the smooth sculptural shape of the lilies are boldly hatched, while a lighter "scribbled" style describes the feathery foliage

thin wisps of grass and the complementary colors of yellow and pinkish-mauve make this arrangement burst from the card

Right: display of lilies
media: pen and ink
This arrangement explodes from the vase like a firework. Although it is full of contrasting shapes and texture, it retains a unity, helped by the diluted washes of tone.

Left: thank you card
media: colored pencil
Presented with a stunning bouquet of flowers, the artist drew this colorful sketch of it on a postcard as a unique thank you to the sender.

great depth has been achieved by adding hatching in mid-tones

darker shading immediately around the flower heads helps them burst out of the picture

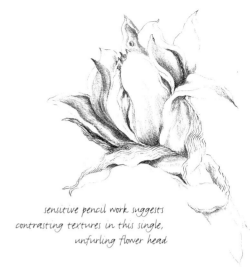

sensitive pencil work suggests contrasting textures in this single, unfurling flower head

Below: on the windowsill
media: pen and ink
The strong verticals made by the glass vase, window frame, and wooden lantern are broken by a single lily stem leaning diagonally into the composition.

the hatched areas of tone in fine pen and ink give this work an illustrative quality

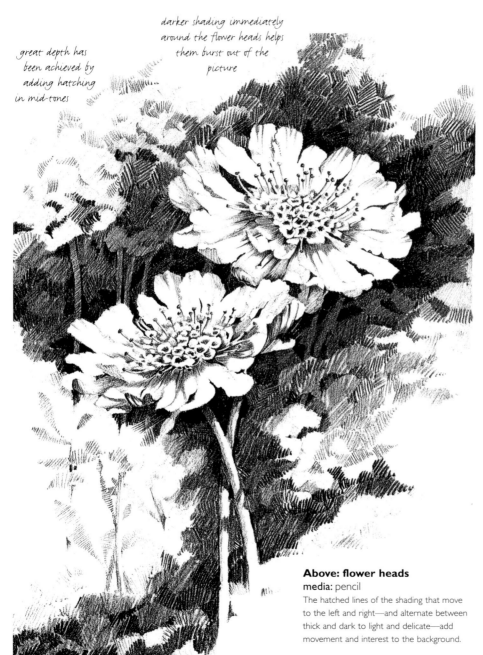

Above: flower heads
media: pencil
The hatched lines of the shading that move to the left and right—and alternate between thick and dark to light and delicate—add movement and interest to the background.

Left: single flower head
media: pencil

The dry outer husk is depicted with fine, wavy lines, while delicate shading is used to describe the soft, moist petals.

Right: arranging flowers
media: photograph

Select just two or three single stems to begin with to focus on shape, light, and a small range of colors, set against a simple background.

a glass vase offers an excellent exercise in light, tone, and reflections

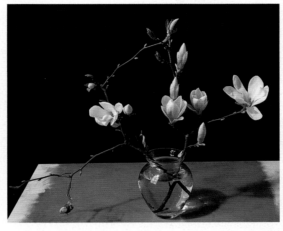

the uniform, square tiles make the daisies appear more fragile and ephemeral

Below: magnolias
media: watercolor

The magnolia flower opens for a couple of days, showing off its elegant, sculptural blossoms before it wilts. Try sketching one flower at various stages, showing the life cycle from unfurling bud to open bloom.

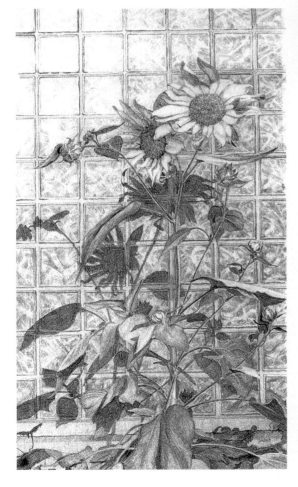

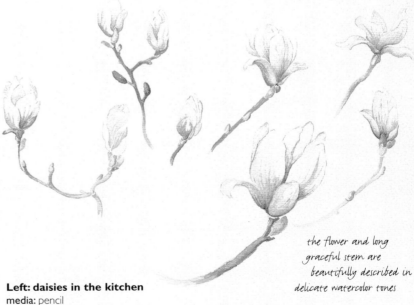

the flower and long graceful stem are beautifully described in delicate watercolor tones

Left: daisies in the kitchen
media: pencil

This sketch is deceptive, as it is made up of only a single stem of daisies and leaves. With skilful lighting, the shadows cast on the tiles behind make it appear a much more complex arrangement than it actually is.

65

Interiors

The beauty of sketching interiors is that they are easy to access, don't depend on good weather, and can vary a great deal in atmosphere: try your own bedroom or workroom—or even the garden shed, greenhouse, or garage. You needn't confine your search to rooms in your own house, although it's obviously a convenient place to start looking. Try taking your sketchbook into a church or temple, a museum, a café, even to a swimming pool. Such places will give you different perspectives on scale and lighting effects, as well as atmosphere.

Start by asking yourself what type of interior inspires you most. Is it uncluttered space, special architectural features, restrained color, and subtle light effects? Or do you feel more drawn to an interior that is intimate, colorful, full of different shapes and textures, and with a wealth of detail. If the latter appeals, you can create one yourself, rather like a set designer assembling a stage. Try draping chairs with colorful clothes or patterned fabrics. Maybe hang some bold prints on the walls. Find a bright patterned rug to put on the floor. Try adding some plants and flowers, artificial ones are ideal.

You might like to consider introducing a narrative element, for example a book left open, a musical instrument resting against the wall, a table laid with a meal, an open cupboard with some of its contents spilling out: they all suggest a human presence although the figures are absent.

Don't forget to take your sketchbook when you go away on vacation. You may find yourself in a place where the architecture, light, and, above all, the atmosphere are quite different and inspiring.

Right: country kitchen
media: mixed media
The touches of watercolor added to this ink sketch create a fresh and cheerful ambience to this rustic kitchen. The window invites the eye beyond the room to the warm day outside.

Left: early evening
media: pencil
This exuberant sketch of a near-empty café could almost have been scribbled on a paper napkin while enjoying a drink and chat on the terrace. The "doodling" nature of this style belies the close observation involved in putting the scene to paper.

the lines of the roof mirror the backs of the chairs

Intricate details can be described in pen, yet the line work is lifted with bright accents of color

the light wash over most of the sketch gives a harmonious feel to the room, and sets off the copper dishes

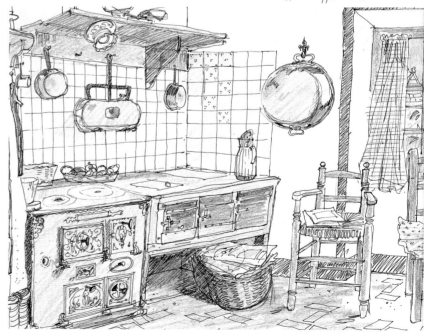

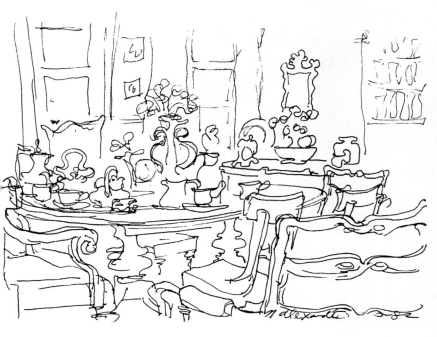

Above: teatime
media: pencil

A simple line drawing, but with a profusion of decorative detail: the mirror on the wall, the vase of flowers on the table, and ornate chairs scattered about.

although busy and detailed, the clean positive lines complement the elegance of the interior

to create the cool, dark atmosphere, the light and tone are an important feature in this sketch

Above: in the barn
media: ballpoint pen

The artist scribbled some notes to herself while making this sketch; "play up dark interiors and dark shadows, silhouettes and highlights… have light in door very strong."

Right: rest in peace
media: mixed media

A halo of light formed around the figure of the knight when the wax of the colored oil pastel was washed over with a darker watercolor tone.

liven up a quick ink sketch with brisk hatchings in colored oil pastel

At home or out and about

Whether in a familiar room in your own home or inside a vast cathedral, the first thing to decide about your sketch is just how much of the interior to include and from which angle to work. You may wish to try several ideas. The faithful viewfinder can be a great help in identifying interesting possibilities in composition. Establish at the offset the vertical and horizontal planes of your interior created by the walls, floor, ceiling, and tabletops. This will set the stage and establish the scaffolding of your composition.

You may find that you don't need many props, the light and shade falling on the angles and planes of an uncluttered interior are in themselves sufficiently interesting to make an inspiring drawing. If you have

Right: Baroque altarpiece
media: pencil
There are all kinds of fascinating structures within an interior. Using simple suggestion in the background, this vast Baroque altarpiece has been placed in the context of an equally decorative cathedral interior.

by including a few figures at the bottom of the sketch, the magnificent scale of the interior is apparent

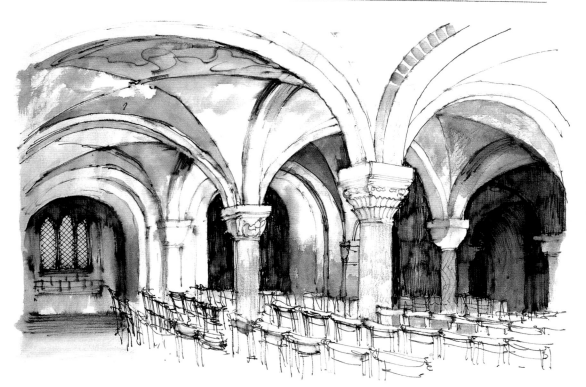

use a water soluble ink pen to make a line drawing, then soften and bleed your work with varying amounts of water for a watercolor wash effect

Right: church interior
media: ink and wash
The artist combines the majesty of this vaulted ceiling with the subtle play of light and shadow in this church interior to create a work that is both grand and meditative.

chosen a room with bare walls and sparse furnishings, a broad, medium-strength charcoal or soft pencil would enable you to deal with the broad expanses of tone. You will need to feel confident about handling perspective or you can use the pencil method for measuring angles.

If you have chosen a cramped and cluttered interior with lots of intricate patterns and details, you will want to aim for decorative effects with plenty of different textures, and, probably, with the introduction of color. You could use colored pencils, watercolor paints, or pastels—either chalk or oil.

The pencil method inside a room

Holding your pencil absolutely vertical and at arm's length, close one eye and tilt your pencil so that it follows the dominant lines of the interior, where ceiling meets wall, and wall meets floor. Then focus on the angle at which you are holding your pencil, estimate it and transfer it to your sheet of paper. Continue measuring in this way until you have sketched in the structure of your interior.

Below: indoor market
media: photograph
If necessary use your pencil as an aid to help you follow lines and angles which will create the illusion of three dimensional space in your interior. With a little practice, using your pencil will become second nature.

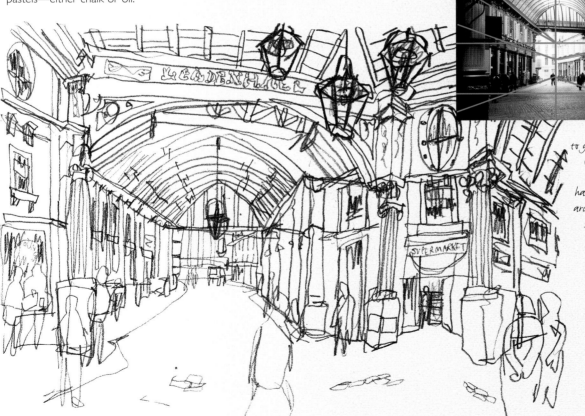

to give the impression of transitory moving figures, the artist has allowed the architectural lines to show through

Left: artistic license
media: pencil
Compare this sketch with the photograph of the same indoor market above. As the sketch proves, the final result doesn't have to resemble anything like an exercise in measured perspective.

Creating a stage

If you have chosen a domestic interior, you can set your own stage and gather props and accessories essential for this purpose. You can choose to focus on these extras and make the architectural elements in the room incidental, in which case it would be sufficient to use just a few lines to suggest the structure of the room. These will contrast with the more intricate shapes of the props as well as preventing them from appearing to float in space.

You could try looking through a doorway from one room to another; the door frame will act as a ready-made viewfinder. Or, for an interesting "interrupted

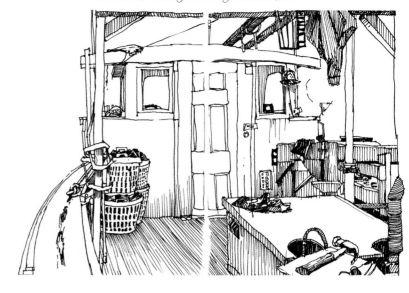

the strength of line in this sketch and the attention to detail give a lively, realistic feel

Above: fishing
media: ink pen
The artist has combined his love of boats, fishing, and sketching to produce an unusual slant on the interior.

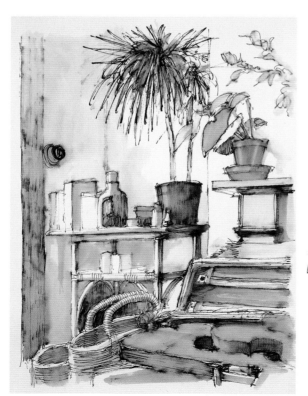

contrast the texture of plastic, glass, metal, and porcelain objects with terra-cotta, wood, plant life, and basketry

Left: household objects
media: mixed media
The corner of the artist's living room offers a ready-made set up for an ink and watercolor sketch.

view," put one of your props in the foreground, such as a large plant, or arrange a table so that the edge appears to jut into the picture frame from one of the lower corners. Such devices add interest to the composition. Mirrors can also make useful props when setting the stage. They can create an intriguing picture within a picture. This may sound complicated, but can actually help to solve some problems as you will be looking at an image that has already been converted from three to two dimensions. Try tilting the mirror slightly to make even more interesting viewpoints. Staircases and hallways, with their strong architectural shapes and levels are also good places to take your sketchbook, especially as you become confident with perspective.

Try sketching your interior at different times of the day—such as when sunlight streams through a window and casts a shadow, or at night under a lamp—and observe how different lighting effects alone will alter the mood of the scene.

Below: violin practice
media: ink pen
Unlike a considered still life
set-up, this violin—simply
propped on a chair—suggests
the artist was impulsively inspired
to make this sketch during a
break from playing.

Right: with friends
media: pencil
Consider using figures as "props"
in your interior, maybe engaged in
an activity as here, chatting
around a table. If sitting time
is limited, draw your figure in
first and then add the
surroundings later.

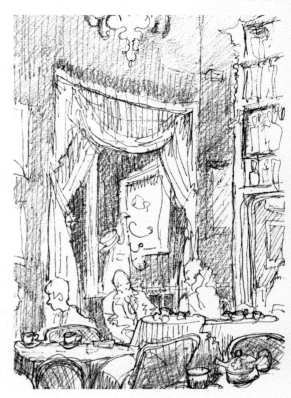

the various textures
of leaves, straw, and
cloth, work well with
the fur of the cat
dozing in the sunshine

the position of
the figures in the
lower half of the
room makes the
room seem larger

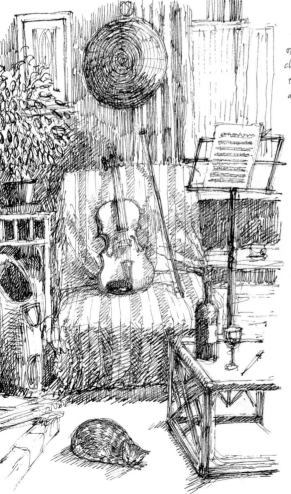

Learning from the Masters

Bedroom at Arles: the
lurid coloring and tilting
angles in the floorboards
and chairs lend this
humble bedroom by
Vincent Van Gogh a
surreal, almost dreamlike
quality. See how you can
make a more thought-
provoking impression
when you use your
imagination to make the
ordinary extraordinary.

focus on details

Interiors usually contain all sorts of interesting objects and details that are good to sketch. Compare just some of the objects on this page to get a small taste of the variety of styles used and the different responses they can provoke. As an experiment, take one or two contrasting pairs and visualize them drawn in the style of the other. Imagine, for example, those currently drawn in charcoal drawn with a fine ink pen instead, and vice versa. It's a useful game to play, as it can alert you to the importance of your choice of media when approaching potential subjects and the corresponding impression you aim to convey.

the blinds become like bars interrupting the view of the world outside

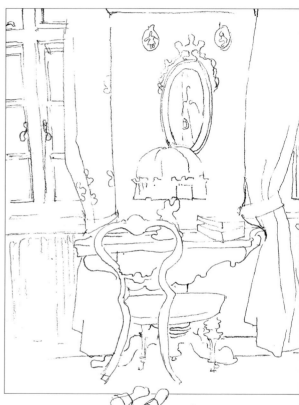

Above: window blinds
media: pencil
Even the vase of flowers and fruit do not relieve the cool and clinical style in which this sketch was drawn. Perhaps it reflects how the artist felt at the time, drawing from her hospital bed.

Left: in the bathroom
media: pencil
Naturally curious to find out what lies behind a door, the viewer's eye is drawn into the picture and beyond by using this clever device of an open door.

the sink becomes an interesting initial focal point within the composition, while the open door leads the eye into the next room

Above: bedroom
media: pencil
Some props, however small and insignificant, can really add something to your work. The simple little slippers on the floor contrast wonderfully with the theatrical and elegant bedroom.

the curvy lines of the chair, drapes, and lamp, bring warmth to this opulent room

ambiguity plays an important role in this sketch and the soft charcoal adds to the mysterious atmosphere

Left: view of window
media: charcoal
The artist conjures a sense of mystery and even imprisonment focusing on just a corner of this unusual interior.

oil pastel and watercolor washes transform sedate tomb architecture

an eraser was used to rub away areas of charcoal to show sunlight hitting the chair, table, and floor

Left: sun on chair
media: charcoal
With the sensitive use of light and shadow, a dramatic effect can be brought to the most ordinary objects.

Right: inside a cathedral
media: mixed media
As oil pastel is water repellent, it remains clean and vibrant even after the application of watercolor washes.

73

Mastering the figure

Once you have gained a degree of confidence in sketching the human subject, almost everything else will be comparatively easy. There are some useful devices that can help you render the figure, but a keen sense of observation and practice is what is really required to gain confidence with this subject.

Life drawing classes are often held at colleges with art faculties, and you don't have to be an art student to enrol. There are also specialist books available that depict photographs of the figure, both nude and clothed, as reference for artists. Drawing nudes will enable you to

gain an understanding of the basic anatomical structure of the human body, while working with clothed figures teaches you how clothes fall and crease.

Spend some time looking at your own body in a mirror. See how resting weight on one leg affects the other. Look over your shoulder at your reflection, see how the skin stretches in one area as you turn and folds in another in response. Detach yourself from what you see, observe your body as a structure, the joints as pivots that move and rotate in certain directions and no further. Try these poses in natural then artificial light to see how different lighting conditions affect color, tone, the contours of the body, and the mood of the scene. Experiment with different techniques, focusing on contour alone. Then focus on just shades of light and tone, trying to create a scene for your figure that evokes a mood and atmosphere.

Use the pencil method of measuring to lightly define the angles of direction and proportion of the figure, then draw the limbs as the basic shapes. Flesh out the shapes by focusing on the gentle contours of the limbs and

the looseness of the linework gives the feeling that the figures are on the point of moving

Above: sketches of standing and bending woman
media: charcoal
Study your own body in the mirror to help understand proportion, movement, and texture.

Left: woman on a cushion
media: chalk pastel
Some dramatic effects can be achieved with strong directional lighting cast on the model.

consider lighting conditions when setting up a pose, as they can enhance the contour, form, and color of your work

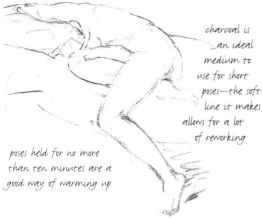

charcoal is an ideal medium to use for short poses—the soft line it makes allows for a lot of reworking

poses held for no more than ten minutes are a good way of warming up

Above: reclining woman
media: charcoal
Working within a short timeframe keeps your style free and the description of the human form to its bare essentials.

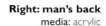

Right: man's back
media: acrylic
Many figure drawings assume a full frontal or profile aspect, but less obvious perspectives can create just as impressive and more unusual pieces of work.

although we don't see the face at all, the strong directional lighting and confident handling of paint make this a wonderfully expressive piece

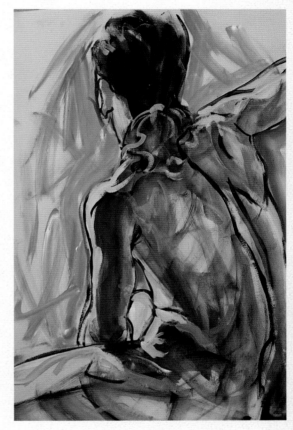

Left: man leaning on an easel
media: chalk pastel
Think about incorporating some simple props. A broom handle provides an ideal staff for your model. Or set off the model against a striped sheet or one or two soft cushions.

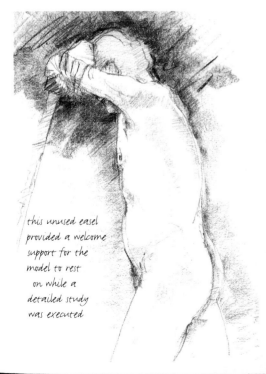

this unused easel provided a welcome support for the model to rest on while a detailed study was executed

feet, like hands, can be challenging subjects—not getting them right can let the rest of your figure study down

Left: study of feet
media: mixed media
Practice by making some concentrated studies from reflections in the mirror or try working from photographs showing feet in varying poses and from different viewpoints to familiarise yourself with their form and structure.

torso. When adding light and tone, let your shading follow the curves of the body to give a sense of form. Imagine you are a sculptor modeling the pose from clay.

The pencil method and the figure

The pencil method of measuring is a simple way of following directions and measuring proportions of the

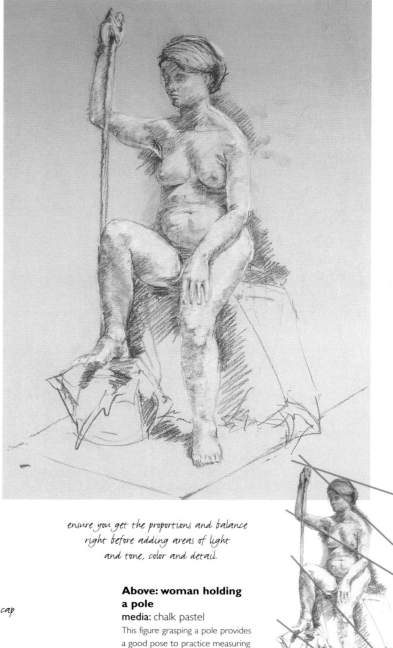

when just starting out with the figure subject, build it up gradually

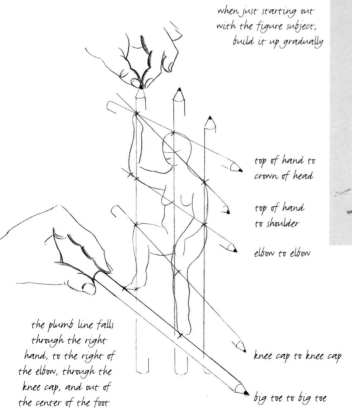

top of hand to crown of head

top of hand to shoulder

elbow to elbow

the plumb line falls through the right hand, to the right of the elbow, through the knee cap, and out of the center of the foot

knee cap to knee cap

big toe to big toe

ensure you get the proportions and balance right before adding areas of light and tone, color and detail.

Above: woman holding a pole
media: chalk pastel
This figure grasping a pole provides a good pose to practice measuring with your pencil.

body using a pencil. Sitting in front of your subject, hold your sketchbook vertically and your pencil vertically at arm's length. Close one eye and tilt the pencil to follow the direction of the lines in your figure. Take obvious points to link—shoulders, hips, and the distance between feet. Now focus on your pencil to estimate the angle you are holding and transfer it to your work. It might take a little practice but you can build up your sketch in easy stages by making these reference points to work from.

Plot further links vertically by using your pencil as a plumb line. Holding it delicately by the tip of the lead, let it hang straight down. This is a good method of gaining a general impression of the movement of the figure in relation to a straight edge and to check important reference points. Lightly sketch out the pose, checking your points as you go. This will enable you to establish the basic structure and balance of the figure before taking your sketch further.

Measuring proportion

You can use your pencil to measure the proportions of the body. With one eye shut, hold your pencil vertically at arm's length, line the tip of your pencil up with the top of the head, and move your thumb to the bottom of the chin; then focus on your pencil.

Notice the distance you have measured between pencil and thumb. Holding that measurement with your arm still vertical, move your hand down so the tip of the pencil now lies on the chin; your thumb will probably lie somewhere in the middle of the chest. Keep moving the pencil down until the whole figure is covered. Using the head as a measuring scale, you will find it will fit about six to seven times into the adult body.

Practice this method of measuring across the body; it's a simple aid to getting the proportions of the figure right in your work. Once you have attuned your eye, feel free

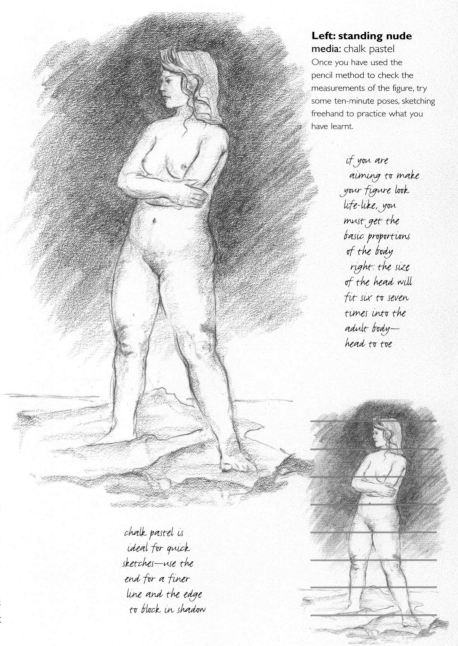

Left: standing nude
media: chalk pastel
Once you have used the pencil method to check the measurements of the figure, try some ten-minute poses, sketching freehand to practice what you have learnt.

if you are aiming to make your figure look life-like, you must get the basic proportions of the body right: the size of the head will fit six to seven times into the adult body— head to toe

chalk pastel is ideal for quick sketches—use the end for a finer line and the edge to block in shadow

77

to loosen up your style and sketch the figure freehand. With a little practice, you will discover drawing the figure from memory will become much easier.

Foreshortening

Think of the human body as a solid, three-dimensional structure like any other. The angles of the body, head, and limbs follow the same principles of perspective that would apply to any object or building.

The pencil method of measuring the figure is particularly useful when drawing some of the trickier foreshortened viewpoints and checking that the proportions of the figure look right when seen in perspective. You have to ignore what your mind knows and trust your observation—sometimes foreshortened limbs, such as an arm coming toward you, will seem too short. Basically, the further objects are from your eye, the smaller they appear. When viewing the figure from a foreshortened viewpoint, it might be easier to think of this the other way round, so the nearer things are to your eye, the larger they appear.

Seeing the figure as shapes

It can often help to simplify the human form and approach it as if it were modelled from cylindrical shapes, rather like a jointed marionette puppet. Lightly sketching in the curves of cylindrical forms as seen in perspective helps enormously in establishing the shape and direction of the limbs, torso, and—on a smaller scale—the fingers and toes. Once you have established the basic "scaffolding" of your figure, you can make it look

Tip: *Before settling down to draw from the model, take a little time to walk around the pose and try some foreshortened viewpoints. They will present an interesting challenge and plenty of practice with the pencil method.*

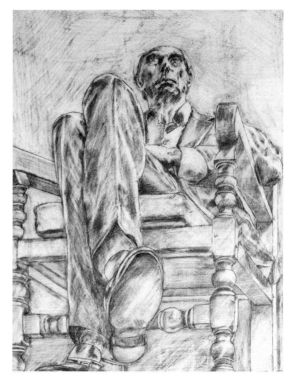

Left: man in armchair
media: pencil
Arriving late to a life drawing class, the artist had no option but to sit almost directly beneath the model. This did mean, though, that a rather boring pose became a much more interesting compositional arrangement by virtue of the viewpoint.

measure the proportion of the head in relation to the sole of the foot to get the scale right

a few lines at the beginning of a study suggesting the angles of direction are invaluable to getting the overall sense of balance and movement right

Right: seated man
media: charcoal
A ten-minute study of a man turning around to look over his shoulder. Poses such as this require you to follow the rotation of the body and head.

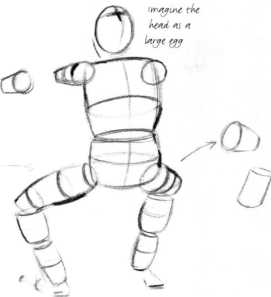

imagine the head as a large egg

another method to help see the shapes of the limbs: the limbs can be simplified into jointed cylinders seen from various perspectives

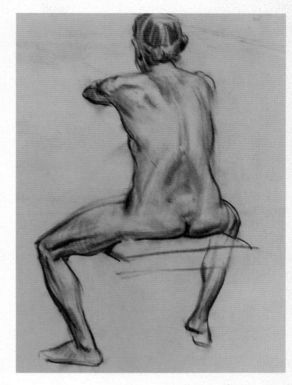

Below: wooden mannequin
Small wooden mannequins of figures are designed specifically as drawing aids from which to draw the figure, and are available from most art stores.

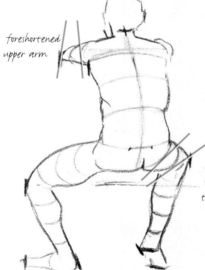

foreshortened upper arm

foreshortened upper right leg contrasting with the length of the left leg

fill out the contour of the figure with the undulations of flesh and muscle

Above: back view of man on seat
media: conté
To help you see the foreshortening of the limbs, measure with your pencil, marking out reference points. Make a note of the length from the tip of the elbow to the armpit.

more life-like by adding the gentle undulations of muscle and body fat to flesh it out.

Hands and feet

The hands and feet, with their intricate joints, can present the artist with challenging foreshortened angles and viewpoints. Familiarize yourself first with their structure by making some studies of them alone. Don't treat them differently from the rest of your figure study by leaving them until last. Aim to include an impression of them in your initial study to make your figure look complete, then add more detail if necessary. Try drawing your own hands and feet reflected in a mirror, or ask someone to pose for you; or you can always find pictures of hands and feet in books and magazines. Reducing them to basic shapes on which to build will help you master them.

the translucent nature of watercolor can mirror the look of light on flesh

a flat squarish pad for the hand with small jointed cylinders for the fingers and thumb

Left: outreached hand
media: watercolor
Practice by sketching your own hands from the reflection in a mirror. Try grasping a cup, holding a ball, or picking up a tiny object to give you a range of poses with one hand while you sketch it with the other.

Left: basic shapes of hands and feet
media: pencil
Compare the simple contour sketches with their shaded counterparts to see how highlight and shadow in these studies largely define the form and shape of the feet. The hands and feet can be reduced to a simple outline of basic shapes.

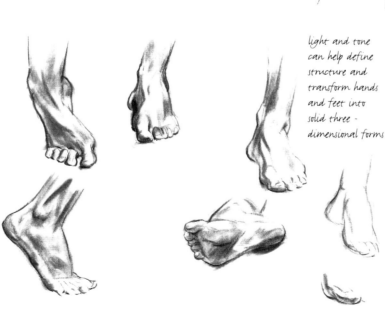

light and tone can help define structure and transform hands and feet into solid three-dimensional forms

the top of the foot becomes the flat top of the wedge

the heel is the thin end of the wedge

Left: studies of feet
media: conté
A good exercise—and reference material for future use—is to fill a sheet like this with studies of feet from as many angles and positions as you can think of.

80

breaking the hand down into a basic shape makes it easier to sketch a hand that is held in an awkward position

each finger is a miniature example of differing amounts of foreshortening

Above: simple shapes
media: conté
A very useful device to help you sketch the figure is to see it in terms of simple geometric shapes. Arms as cylinders, fingers as smaller cylinders, the head as an egg shape, and feet as triangular wedges.

making highlights with an eraser gives the arm a muscular appearance

pointing, grasping, and clenching your own hand can provide useful poses

Above, left, and right: gestures
media: charcoal and color pencil (right)
Working from your own reflection is an invaluable and ready source of reference material, enabling you to add finishing details to figure work or simply getting the structure and proportions of the body right when working from memory.

the artist has reflected the color of the sweater in the flesh of the hands—a visual link that creates a harmonious effect

Try a short pose

Your figure is a living, breathing subject and short poses of about five to ten minutes are excellent exercises in conveying the vitality of life with line alone. A degree of confidence and familiarity with the figure is required in making a successful sketch from the short pose.

Knowing your time is limited can be useful as it accustoms your eye to focus on the essentials of balance and movement in the contours of the body. It can be frustrating at first: you might feel you are just getting there and then the pose has gone. Persevere, you will find that practice with short poses will really help you when you take your sketchbook out. There is so much in the world that won't wait to be drawn, but if you see something that captures your imagination, get it down quickly on paper.

Choose a media that will enable you to work quickly and easily. My favorites are charcoal and a light-colored chalk pastel on a mid-toned paper—a neutral gray or deep cream—to become the body color of the subject. Map out sweeps of movement in limbs and clothes in a linear sketch, then concentrate on areas of shade and highlight to give a sense of solidity. If you have time, you can start working on the finer details, expression and textures, or sketch in the suggestion of floor, walls, and shadows, so your figure is seen in the context of an environment and not floating in space.

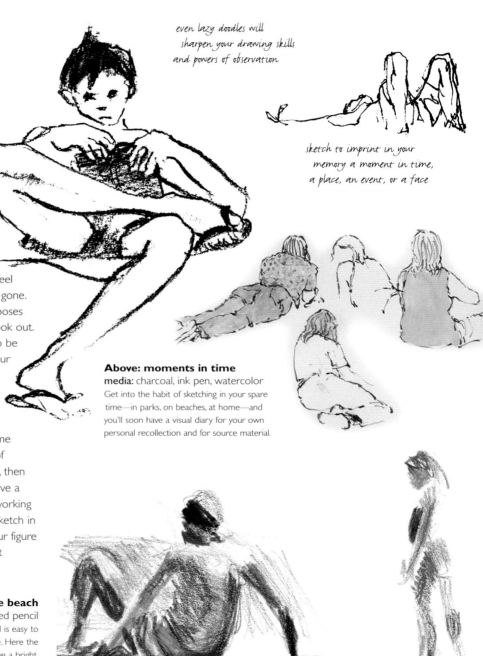

even lazy doodles will sharpen your drawing skills and powers of observation

sketch to imprint in your memory a moment in time, a place, an event, or a face

Above: moments in time
media: charcoal, ink pen, watercolor
Get into the habit of sketching in your spare time—in parks, on beaches, at home—and you'll soon have a visual diary for your own personal recollection and for source material.

Right: on the beach
media: colored pencil
Colored pencil is easy to transport and use. Here the flashes of color give a bright, sunny result.

82

Learning from the Masters

Pentimento: Imagine this same subject refined into a finished painting. As well as the pentimento marks being lost, so too would some of the spontaneous energy captured here. This work in **chalk** by **Leonardo da Vinci** shows why so much preparatory sketch work is considered as great art in its own right.

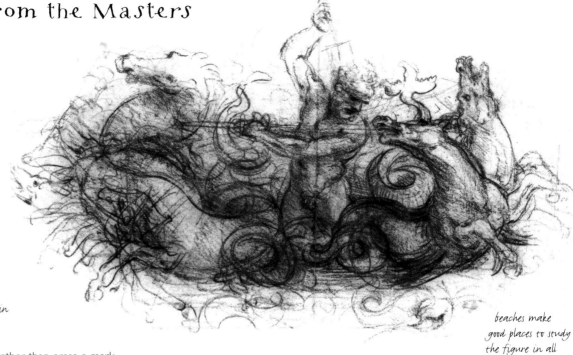

the legs of the sea horse on the left form an arc of frenzied movement in an almost photographic sequence of stills as it rears up under Neptune's tight rein

Pentimento

In Italian Renaissance work, rather than erase a mark which might have been drawn in the wrong place, it was left on the page and simply redrawn. These marks are called pentimento marks, from the Italian for "repentance." Over the course of refining the sketch, these marks ultimately created a lively piece of work shimmering with vitality. So when working on short poses, leave the eraser alone. Pentimento marks add liveliness and a sense of movement to your sketch. If it doesn't work the first time, rework rather than rub out.

Right: people-watching
media: conté
Redefining and redrawing will breathe movement and life into figure work. Work on a paper with a slight "tooth."

start by using the end of your conté stick to lightly define the contours of the body

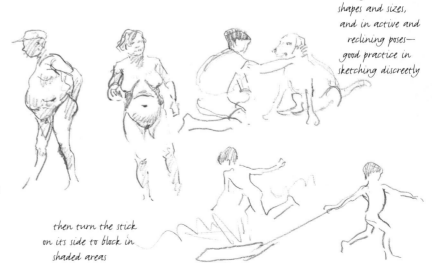

beaches make good places to study the figure in all shapes and sizes, and in active and reclining poses— good practice in sketching discreetly

then turn the stick on its side to block in shaded areas

Working with a long pose

By having a model sit for a long pose you can make a more concentrated study of the figure as well as having more options to explore ideas. Consider your lighting conditions and the light cast on your model. A naturally lit interior away from the sun will enable you to study the subtlety of flesh tones and the gentle undulations of the human form. Sunlight or strong artificial light, on the other hand, will tend to bleach out tones but throw the figure, facial features, and creased clothing into dramatic sculptural contours of light and shadow. Think about the pose itself. It could be active, in repose, or viewed from intriguing perspectives, such as through the leaves of a large plant or through a doorway. Try integrating the figure into his or her surroundings—either make the model a central feature to your composition and the surroundings simply a backdrop, or make the figure interact with the setting. The figure could be seated reading at a table with a still life of scattered papers and open books, or looking out of a window to the view beyond.

Clothes as props and accessories can add narrative interest as well as enlivening the work with color and texture. Smooth silks cling and show off the contours of the body, while a colorful woolly sweater will contrast with the softness of the flesh. Create decorative effects by adding bright cushions and draping patterned fabrics over chairs and floors. Have some fun and bring a touch of theater to your work.

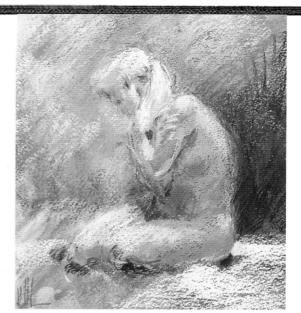

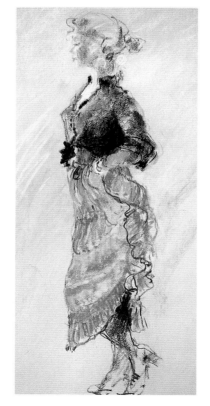

Right: woman in ruffled skirt
media: chalk pastel
Traditionally models were draped, usually with a plain loose fabric. This was then carefully arranged to hang elegantly from the model so the contrasting deep shadows and highlights falling on pleats and folds could be studied.

Left: seated figure
media: chalk pastel
You don't always need to stick to the truth of what you see. Try experimenting with some unusual and imaginative color combinations to enliven your figure work.

unexpected color mixes can set a different mood to the overall piece

Sustaining a pose
Consider the comfort of the model and take regular breaks. Traditionally chalk lines are drawn around the pose to set it right again. This may not be possible, so it may be worth making a brief thumbnail sketch to refer to before you start on the long pose.

using variations of a color for a whole piece adds unity

Above: reclining nude
media: chalk pastel
Chalk pastel is often chosen as the media for figure drawing for the bold and lively effect it achieves.

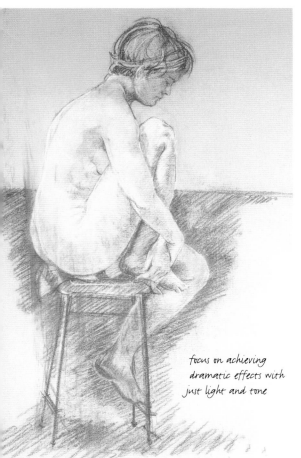

Left: nude on stool
media: chalk pastel
Earth colors such as deep rust browns for shaded areas with a rich cream for highlights can work well together. Try sketching these on a toned paper letting this become your mid–tone and body color.

try some studies limiting your colors to just one or two restrained tints

focus on achieving dramatic effects with just light and tone

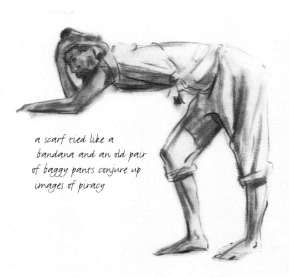

a scarf tied like a bandana and an old pair of baggy pants conjure up images of piracy

Above: man in costume
media: conté
Have some fun and bring a touch of theater to your work— try dressing your model in a costume.

the meditative calm state before the whirling ritual dance of the dervish

Right: whirling dervish
media: pencil
This statuesque draped figure of a dervish seems to revolve slowly as the artist depicts him from different viewpoints.

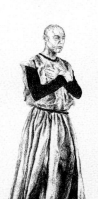

85

sketch a group

The subject of a figure group can embrace anything from the most intimate, such as a lone couple out walking, to a vast audience of people presenting a heaving mass of color and movement.

Firstly, take a look around you and observe how people interact. You will see the body language between individuals and how it varies from situation to situation. There will be very little body language between strangers standing in a bus line. Instead you will notice a bubble of personal space around each person. When you close that space between a couple of figures you automatically assume they are acquainted with one another.

Aim to capture something of the character of your subjects and how they relate—or, for that matter, do not relate—to one another. This can bring an interesting narrative to your work. By comparing some of the examples on this page, you will see how feelings such as intimacy, isolation, friendship, and formality can be expressed with a figure group. An elderly couple on a beach, a carefree group of children, some thoughtful visitors at an exhibition, a huddle of men conversing around a campfire, a busy restaurant or café scene populated with anonymous individuals.

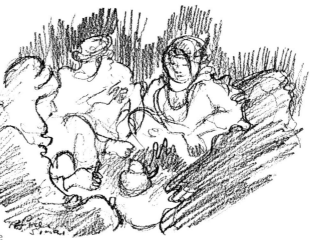

Left: around a campfire
media: charcoal pencil
The huddled gathering of men around a campfire, and the back view of some, suggest an intimacy that the viewer is not a party to.

the foreground figures are almost simple silhouettes leading the eye into the central focus point

the little bubble of personal space around each individual in this group suggests they are privately engaged in their own meditative thoughts

Below: gallery goers
media: watercolor
Galleries and museums are good places to sketch figure groups. Not only will there often be a central seating area, but the calm and slow pace with which people view exhibits will give you time to complete some unhurried studies.

Left: strolling
media: chalk
The artist has cleverly observed that there is a reflection and a shadow to be captured.

to capture the scene, figures and portraits were drawn in quickly—if the sitter moved, the face was left unfinished, but enough information was drawn to create the ambience

the artist's use of pencil, ink, and watercolor create a whimsical feel

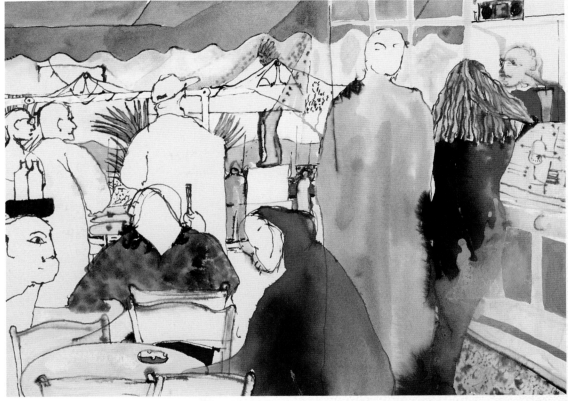

Left: eating out
media: mixed media
The decorative composition and seeping color washes of this piece evoke an unusual presence and ambience in this busy restaurant scene sketched while on vacation in a foreign country.

the lack of detail adds to the liveliness of the scene

crouching over a game, these two children are playing in perfect harmony

a few background details place these children in their environment

Right: children playing
media: chalk
Children generally won't wait around to hold a pose for long, but this can have its advantages. Brief sketches of children before they "fly" can effectively capture more of the nature of their restless energy than longer considered studies.

Gatherings

Find a place to sketch a city scene and observe figures—such as from a café overlooking a square or in a car parked in a busy street. You might sense the anonymity of the people you see, wandering among even more anonymous buildings. Some might be walking purposefully, going about their day's business, others could be loitering, looking a little lost or waiting in line. Art museums are good places to observe people in a hushed and meditative context. Figures here tend to move slowly, at a considered pace in quiet concentration. In contrast, you could focus on the movement and energy of a child's birthday party, a busy fast food restaurant, or an airport terminal. A family around the breakfast table in a frenzy to get to work and school on time can also be a good study in movement if you are not part of the early morning rush.

You could try tackling a crowd scene at a sporting event, or an audience at a concert. Rather than looking for individual figures or faces, concentrate on the overall effect of movement *en masse*.

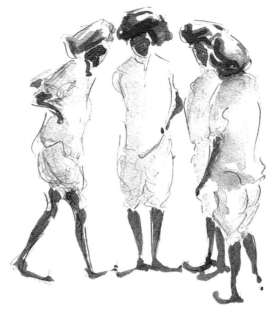

Left: deep in conversation
media: watercolor and pencil
There are no individual details in this gathering of friends, yet the bold use of color and light make this a work brimming with character.

the free paint and line work show how expressively a figure group can be conveyed with an economy of means

use a variety of colors to define your subjects and to create a sense of shimmering movement

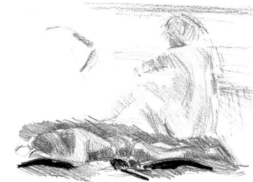

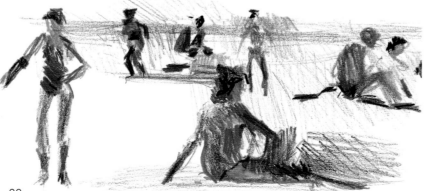

Left and above: relaxing on the beach
media: color pencil
Beaches and parks are excellent places to find source material. They are a visual feast of light and color, of costumes, and beach umbrellas, and provide a good mixture of active and reclining poses to sketch from.

try this experiment: resist expressing your figures with lines but try some quick ten-minute sketches with hatching

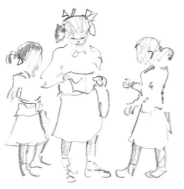

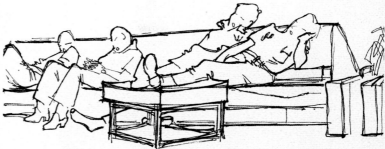

this artist uses a simple illustrative style to capture his young subjects and puts separate studies together to form small groups

the slumped postures of tired passengers waiting for a flight add to the sense of passing time

Above: children mid-chat
media: chalk
If you can catch them for long enough, children make great figure groups. They interact so readily and with such enthusiasm.

Above right: waiting for a flight
media: pen
This simple sketch of exhausted travelers jotted in an airport waiting room simply but brilliantly captures the monotony of a delay.

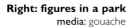

Right: figures in a park
media: gouache
A small group of figures make a charming memento of a lazy afternoon in the park. This small painted work was only a few centimeters across, and could have easily been completed in an afternoon.

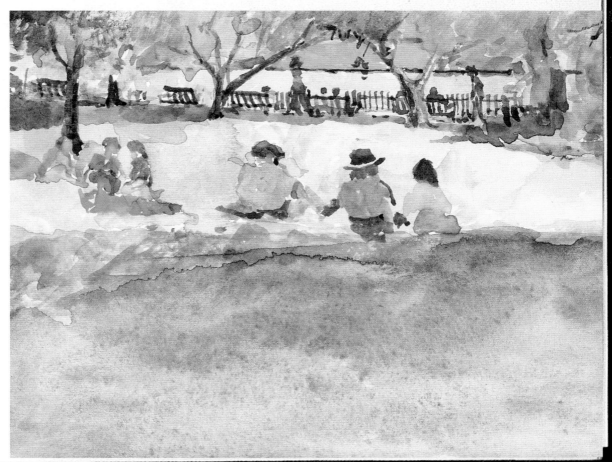

if you are traveling to a place where you know the landscape will feature in your work, a sketchbook in a landscape format will be useful—when opened up over a double page spread like this, you will have a panoramic area on which to work

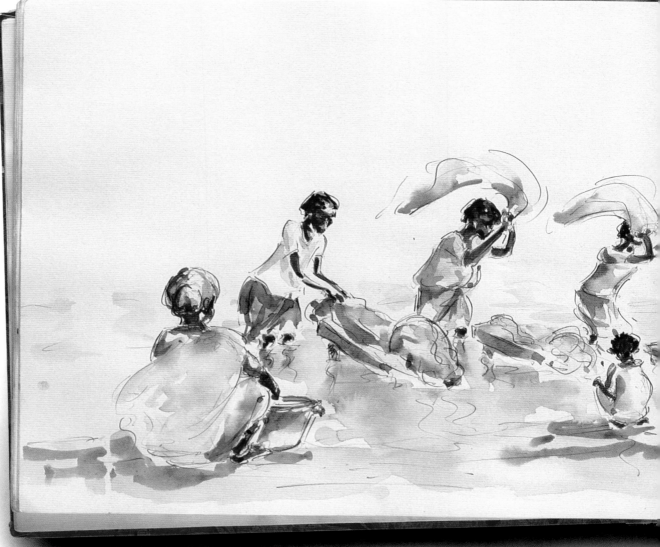

the profusion of bright primary colors make this painted sketch dance with lively activity

the long burnt umber shadows of the figures cast over the sand conjure up the warmth of the Indian climate at the beginning of the day

The Dhobi Ghat, Varanassi
media: mixed media

On her travels in India, the artist has captured the play of sparkling color and light in this watercolor scene of the daily washing rituals on the banks of the sacred River Ganges.

Dhobi Ghat — Varanasi

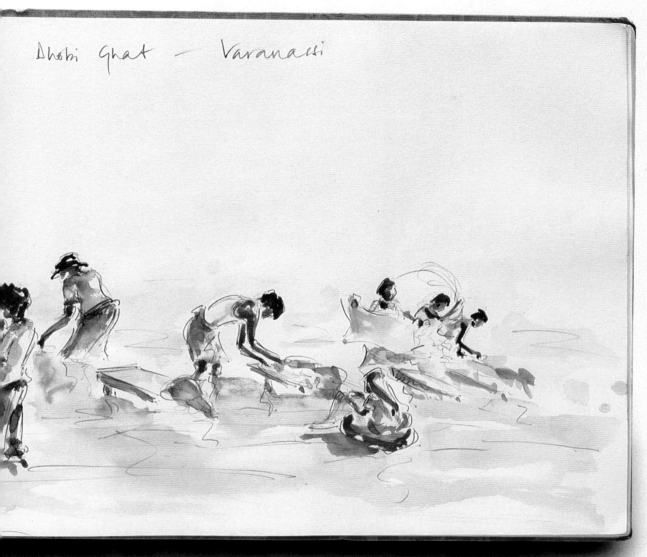

the impression of recession and space is skilfully achieved by making the figures gradually diminish in size along the water's edge

the brief initial pencil sketch showing through the watercolor brings a sense of movement and vitality to the finished work

in the shallow water, delicate pale washes capture the reflections of the brightly colored fabrics

Although every person's head contains the main features of eyes, mouth, and nose, you only have to look about you to see the quite astounding range of variations that the head alone presents. Differences in skin and eye coloring, hair texture, face shape, and expression make each and every person unique.

Yet, despite this diversity, arrangements of the main features are relatively constant. By acquiring an understanding of the basic structure of the head and features, we can get the proportions right to make our portrait.

Begin by studying your own face in the mirror. Really examine each of your features in turn. Use a handheld mirror to reflect your profile and to view the contour of the nose and the rather complex structure of the ear. As you move your head, so the perspective, light, and

Below: bearded man
media: conté
Use an eraser to create areas of highlight in your work with charcoal. See how light from the white paper beneath shines through.

The Portrait

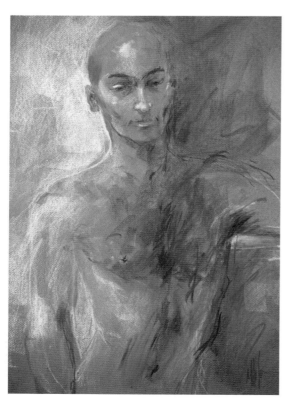

shade falling on your face will change.

First sketch a self-portrait head on. Then try sketching a model's head viewed from different angles—a willing friend may oblige, or look at photographs in newspapers or magazines. Choose plenty of men and women, and analyze the different shapes of their noses, mouths, and ears.

highlight the hair, forehead, and beard with your eraser

adventurous color and a free gestural style bring liveliness and movement to this study

a highlight exaggerate the strong profile shape of the nose

Left: man in pool of light
media: chalk pastel
Explore the different sense of mood and character you can bring to a portrait by experimenting with different color combinations.

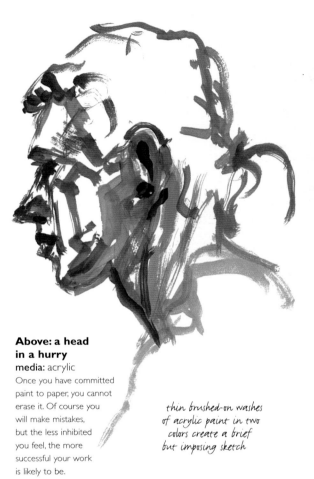

animate eyes by adding just a dot of bright white highlight

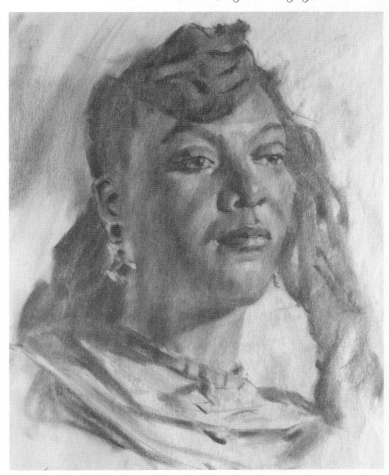

Above: a head in a hurry

media: acrylic

Once you have committed paint to paper, you cannot erase it. Of course you will make mistakes, but the less inhibited you feel, the more successful your work is likely to be.

thin brushed-on washes of acrylic paint in two colors create a brief but imposing sketch

Tip: It is useful to look at and sketch from portrait drawings and paintings, and even caricatures by accomplished artists, which will show you the sheer range of styles and techniques that can be used in portraying the human head.

a three-dimensional quality is given by shading most of the right side of the model's face— even the details are thrown into the shadows

Above: sculptural portrait

media: conté

Consider your lighting conditions if sketching dark-toned skin and aim to exploit its wonderful reflective qualities to make a powerful sculptural study.

93

Sketching a short pose

Portraits of the face are animated by expression. When happy, all the features lift; when downcast, they appear to sag; when relaxed, they look softer. The eyes and the mouth in particular give away the mood of a person. Sketching the stance of the whole upper part of the body can also accentuate the expressiveness of your portrait. Look at the perspective of the head and neck held in relation to the body: slumped onto the chest with tiredness or craned upright and alert; leaning forward engrossed in study or lounging backward, eyes gazing into the distance. Take a look at caricatures in newspapers of celebrities and politicians, the skill lies in exaggerating features and poses yet still retaining a true likeness to the subject. Remember that the size of forehead, width between the eyes, and shape of the jaw line are as important as the main features of eyes, nose, and mouth in capturing a resemblance to your model.

Capturing characteristics

To start capturing characteristics, catch a friend or family member in a pose—in front of the television, reading a book, or eating a meal, for example. Cafés are good places to sit and discreetly observe a variety of people and faces, so carry a pocket sketchbook and a pencil or ink pen with you to take out at any given opportunity. Once you have chosen your subject, take a moment to observe the head and note any distinguishing features. Start to make simple line drawings.

Concentrate on contours and positioning the main features and don't get too involved with details at this stage. If your subject changes position, simply start another study on the same page. A moving subject provides the opportunity to view a different angle of the face. Think of your sketches as a jigsaw, piecing together visual information such as tones, textures, and details as they present themselves. If your subject stays still for a while, you can extend your studies, perhaps by including some background to place the portrait in context.

varying degrees of hatching create lively marks and differing tones

Below: photography as inspiration
media: oil pastel
This portrait was worked from a collection of old black and white photographs that had inspired the artist by their expressiveness. It is a good observational and drawing exercise to reverse the process and draw white on black.

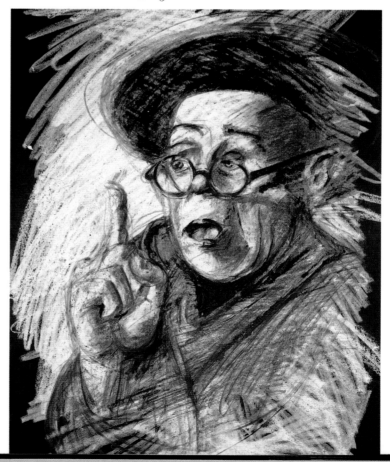

strong contrasts of light and dark with white oil pastel on a background of black card

Above: musicians
media: pen
and pencil
The intensely concentrated
expressions of this pair of violinists,
listening out for their time
to come in, moved the artist to
make this sketch on the back of
her concert programme.

*a quick sketch can
carry as much
atmosphere as
a long study*

Below: friend with flu
media: pencil
I quietly drew a friend ill with the flu as he tossed and turned
in bed. When he finally settled to sleep I was able to make a more
detailed study of his face.

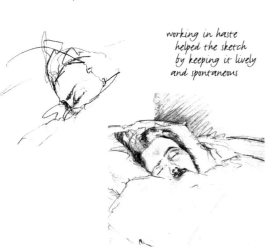

*working in haste
helped the sketch
by keeping it lively
and spontaneous*

Learning from the Masters

Portrait: "Nick and Henry
on board, Nice to Calvi."
This delicate line drawing
by **David Hockney**,
executed while passing
time on a long journey,
makes a delightful personal
memento, as well as
a skillful **pen and
ink** drawing.

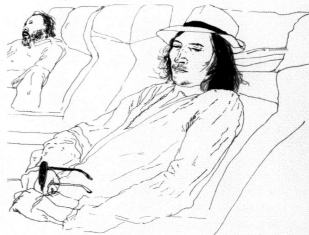

*the sensitive and economic
handling of the shading frames
and emphasizes the main
features of the head*

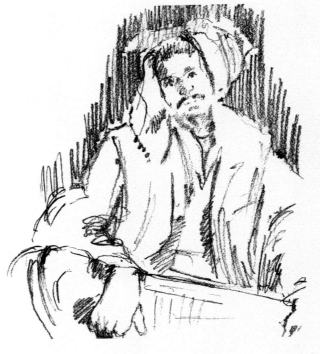

*to define and throw
the figure forward,
the artist sketched
in a dark background
using vertical strokes*

Left: man in café
media: charcoal pencil
Once you have gained some
practice and experience in
portraiture you will be able
to make brief but accomplished
sketches which will delight those
who pose for you.

Aim to fill a few sheets of your sketchbook with portrait studies and you will really appreciate the rich diversity of the human face.

Study of the main features

The eyes are truly windows to the soul and should be as expressive in a portrait as they are in reality. As an experiment, try sketching first light colored eyes in your work, then make them dark—you will see the different impression they make to your portrait.

The ears, mouth, and nose are molded structures. Lips are fleshy and soft while noses and ears are composed of firm but malleable cartilage. Take care when drawing lines to define these features, they could look artificial. Express the lips in light and shade, try lightly sketching in their outline for guidance, then complete with tonal shading or cross-hatching to define their form.

Hair encompasses all colors and textures. To capture the texture of hair you will need a good light source, otherwise the hair will have a flat, allover color. With your model in strong directional light, study the different ways the hair can catch textures. Squint your eyes to reduce the hair to shades of light and tone.

the mouth will fall just below the bottom of the nose

the tops of the ears are generally level with the eyebrows

simulating the light and shadows with pencil lines will add life to your portrait

with experience, you won't need to draw in the reference lines

Left: the structure of the head

The form of the human head closely resembles an egg shape. Sketch in a central vertical line running right around the egg from the top to the bottom, bisected by a horizontal line about halfway down. This is the line on which you will position the eyes. You can then set down all the other main features of the face in relation to the eyes. Draw in a small dash to establish the bottom of the nose on the vertical line running between the eyes.

Above: positioning the features

If the face is turned to one side, as here, draw a second vertical line bisecting the first through the middle. This will give you a line on the side of the head on which to place the ears. When drawing from the model, always start by building up these important reference marks over the head and constantly refer back to them to check they are correctly positioned in relation to one another.

Left: adding detail

Once you have everything in place you can concentrate on the unique characteristics of the features.

96

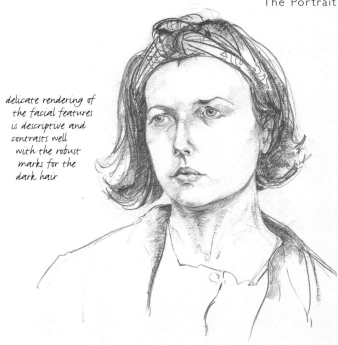

delicate rendering of the facial features is descriptive and contrasts well with the robust marks for the dark hair

Below: balding man
media: conté
The ears make an interesting sculptural study, but unless you are doing a close-up profile view of your subject, then a general impression of the ear will suffice.

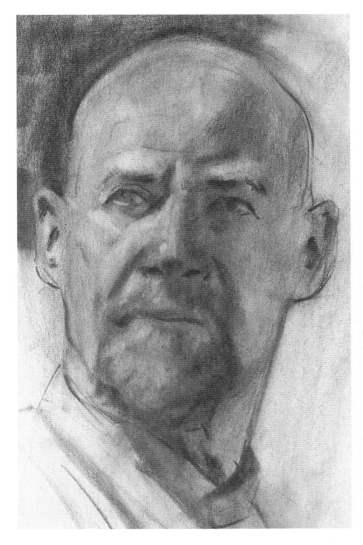

Above: Marion
media: chalk pastel
To begin with, it is important to gain a good understanding of the human form and its features, as well as learning the techniques in which to render it.

the ears look like two loops— one smaller loop inside another

imagine your soft stick of charcoal as a smooth spatula and that you are sculpting the nose and mouth in soft clay

Left: cameo of nose and mouth
media: conté
From this study of the nose and mouth, it is evident how much of their definition relies on the fall of light and shadow.

Completing a long pose

Begin by trying some monochromatic sketches, concentrating on form, structure, and lighting effects. Once you have gained confidence rendering the head, you can enliven your portrait with the colors and textures of the hair, flesh, and clothing. It can be bright and exciting, or subtle and understated—sometimes just a touch of color on the lips and eyes will bring your portrait to life.

Right: blond man with beard
media: conté
The self portrait makes a good starting point with portrait work,. However familiar you feel you are with your own features, you will discover something new each time you sit down to draw.

Right: reflective pose
media: chalk pastel
The model sits directly facing the light source, which has the effect of creating a powerful illuminated profile.

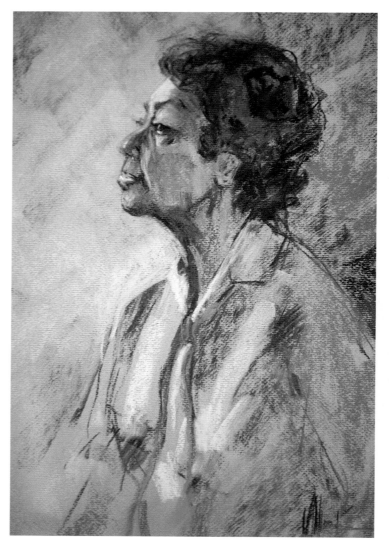

the underside of the top lip appears darker than the bottom lip, because it is in shadow; likewise there is shadow just below the bottom lip

the texture of the paper is allowed to shine through and gives life to the surface drawing

strong directional light emphasizes contour, light, and shadow

Siting a portrait

Traditionally, portraits were composed in an upright portrait format, but you can use a landscape format. If your model reclines on a sofa or in the bathtub, the landscape format would work well. Place your model in a setting with props to create a narrative element, at the breakfast table maybe, with a still life set-up. Or evoke a pensive mood as your model reads a letter by

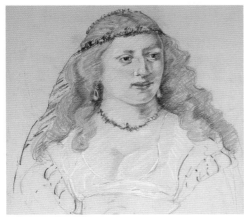

Above: after Rembrandt
media: chalk pastel
The artist chose this figure from a postcard of an oil painting by Rembrandt. Transcribing the work of the masters will allow you to concentrate on the structure and proportions of the human head without the time pressures of working with a live model.

curly hair picks up highlights on its waves, whereas frizzy hair can appear to absorb light

long straight hair tends to reflect light in streaks

Right: Emma
media: chalk pastel
With the above Rembrandt transcription as a model, the artist's aim was to make a portrait focusing on color and texture. Using different techniques with chalk pastels, she worked over the sweater quite quickly and roughly as opposed to the smooth blended tones applied to the face and hair.

a window. Sketch short poses first, trying out a few ideas before settling on one that appeals, and then extend your pose to enable you to complete a considered piece of work. A long pose will enable you to make a considered study and place your model in the context of his or her setting. Start with a self-portrait to get the proportions of the head and features right. Maybe a friend or family member will hold a pose for you, particularly if they are distracted by a book, playing an instrument, or even asleep.

warmer tones add depth and solidity to the longer study

Below and right:
Kate playing the violin
media: watercolor
A quick watercolor sketch and longer study in preparation for a finished painting. See how the artist has worked up and intensified flesh tones and the colors of the polished violin to create a more focused and sharper image. Yet the lighting and subtle colors of the preparatory sketch beautifully capture the mood of calm concentration as the young girl makes music in a sunlit room.

highlights are created by leaving the paper white to give shape to the violin

as with the quick sketch, a faint pencil outline helps the artist work quickly when painting

strong directional light
adds an airy atmosphere
to the sketch

watercolor is loosely brushed in; the wet colors
are allowed to merge into each other

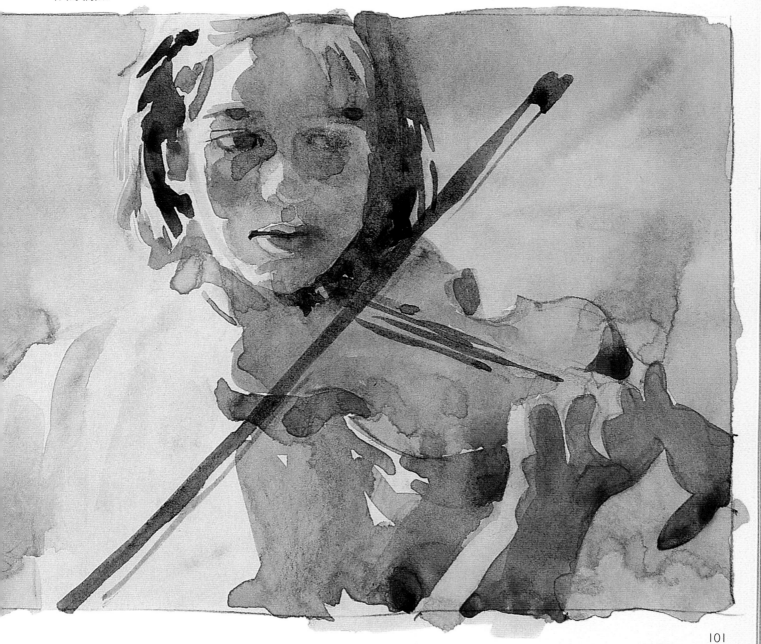

The animal kingdom presents so many species to choose from, yet your greatest challenge may be capturing your subject for long enough to study it.

Animals

If anatomical structure and texture are what interest you, it might be worth investing in a camera with a good lens. That way, if you can't get close to your subject, you will at least be able to focus on features such as the eyes, nose, mouth, teeth, or claws. To study the anatomy of an animal in motion, you can freeze-frame a video of an animal running or flying. This will present you with a sequence of stills from which to study.

Like humans, animals have personalities, and by observing them from life you can pick up on their individual characteristics. For example, the ambling gait of the tiger can express an absolute ease in his environment or complete boredom, depending on whether you observe the big cat in its natural habitat or caged in a zoo. A bird that might move with a jerky nervousness on the ground, may be graceful in flight. By spending some time observing and sketching a subject from life, we can sense the true nature of the beast.

despite the furry coat, the form of the monkey is still apparent by the way the artist has left clear the highlights on the body and limbs

Right: study of a monkey
media: pencil

A friend kept this monkey at a zoo occupied while the artist made a quick sketch of its upturned face, but he soon tired of the game and moved off. Luckily, another monkey sitting relatively still enabled the artist to complete the body and limbs.

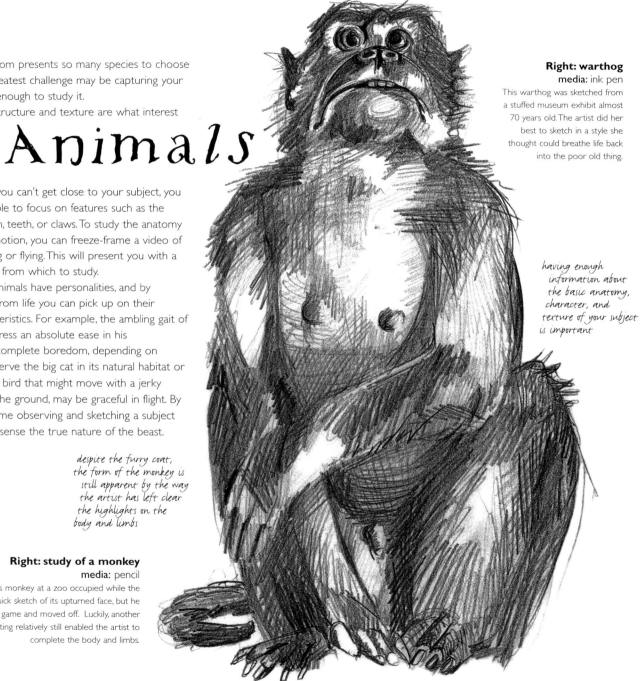

Right: warthog
media: ink pen

This warthog was sketched from a stuffed museum exhibit almost 70 years old. The artist did her best to sketch in a style she thought could breathe life back into the poor old thing.

having enough information about the basic anatomy, character, and texture of your subject is important

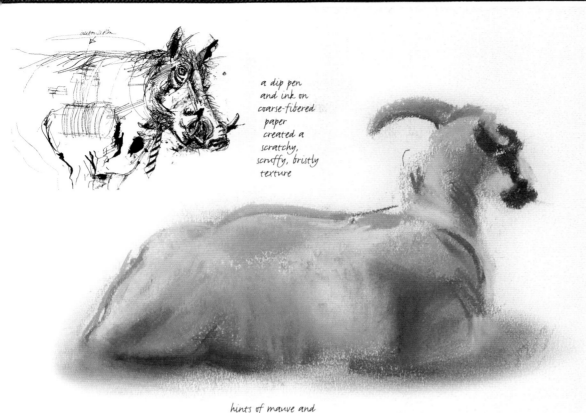

a dip pen and ink on coarse-fibered paper created a scratchy, scruffy, bristly texture

Left: goat at ease
media: chalk pastel
Imagine this study but without the touches of color and you will appreciate how the artist has made this sketch of a reclining goat into something more unusual.

Below left: circling fish
media: pencil
An elegant composition is achieved in this arrangement of studies of ornamental fish.

Below: cow
media: pastel
Earth-colored chalks are particularly suited to tonal studies of the animal and figure subject. They can achieve a similar range of density as charcoal, but without the sootiness, giving a brighter and softer overall result.

hints of mauve and emerald suggest the cool light of evening

farm animals make good subjects for detailed studies—there is always at least one animal lying around

you only need one fish to create a composition, simply fill your page with studies and then you can arrange them

the artist has foreshortened the body and still captured the animal's bulk by careful observation and perspective drawing

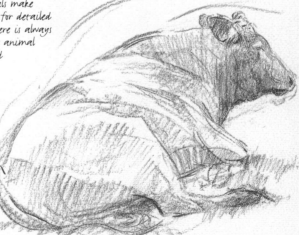

Right: a cat of many guises
media: pen
The artist follows his model's movements around the sketchbook page with the pen as the cat repositions itself time after time. Finally, the cat settles to wash itself, enabling a hasty cross-hatched sketch to be made.

by going with the flow, an exciting composition and almost abstract design emerges

A good starting point is a pet, but if you don't have one, try capturing birds in flight, ducks in the park, or other animals in a field, a zoo, or on a farm.

Keeping it fluid
Unless your subject is either fast asleep or a tortoise, then it will rarely keep a pose long enough for you to complete any sustained or detailed study. As you can never anticipate where animals will take themselves next, you must work with a fair degree of haste and so learn to become less self-conscious about committing pencil to paper. Animal subjects are a great way of loosening up your working method and they will keep your style fluid.

Below: sleeping cat
media: pencil
Cats are quite happy to sleep for the greater part of the day making them ideal subjects on which to practice.

take advantage of a still pose to study the form and texture of your subject

Right: Sooty grooming
media: charcoal
Although the subject kept shifting, the redefined contours bring a sense of movement to the work which saves it from being static.

adopt a simple style and "go with the flow"

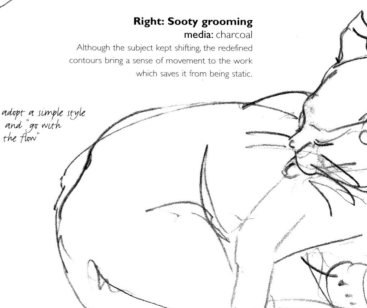

*beware of sentimentality—
focus instead on really
trying to capture your
pet's character*

*the outline shape and form
of the dog has been achieved
by drawing the fur in at
"rayed" angles around the
body—cleverly capturing texture
and form simultaneously*

Above: Buster in a basket
media: pencil
This little sketch really captures the
fondness the artist holds for the
family pet without the slightest hint
of mawkishness.

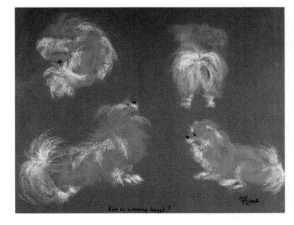

**Above: quick sketches of
Kim on toned paper**
media: chalk pastel
The same effects just couldn't be
achieved on a white background so it
is always worth slipping in a few loose
sheets of toned paper among the
leaves of a standard sketchbook.

*toned paper can
really exploit
highlights of color
and texture.*

*the dry media of pencil,
charcoal, and pastel are ideal
for making brief yet
informative studies to take into
further work*

Above: sleeping dog
media: charcoal pencil
Working with a degree of haste, as you
never know when your subject will
move or wake, can produce some
wonderfully lively sketch work
bursting with character.

105

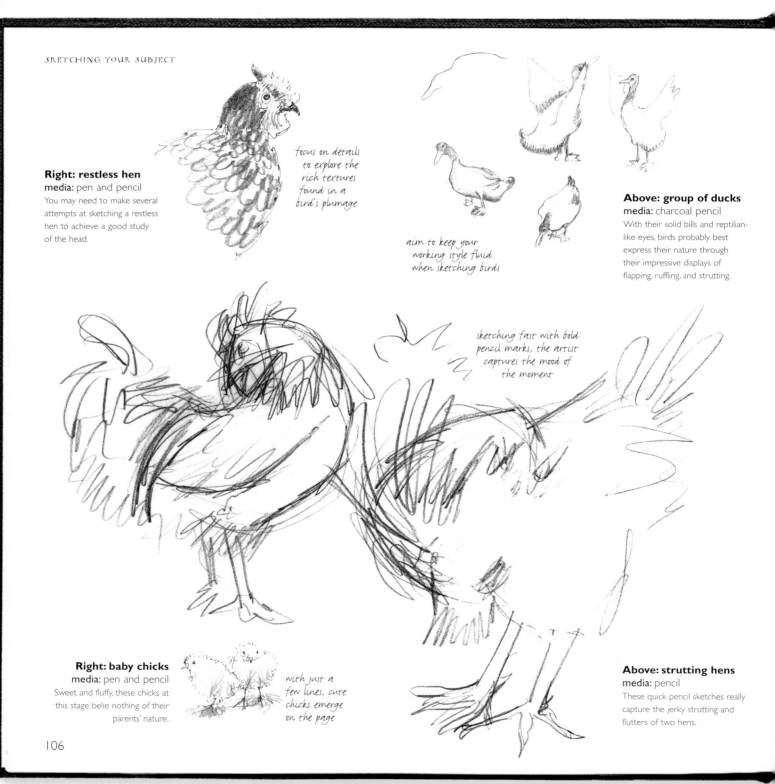

Right: restless hen
media: pen and pencil
You may need to make several attempts at sketching a restless hen to achieve a good study of the head.

focus on details to explore the rich textures found in a bird's plumage

aim to keep your working style fluid when sketching birds

Above: group of ducks
media: charcoal pencil
With their solid bills and reptilian-like eyes, birds probably best express their nature through their impressive displays of flapping, ruffling, and strutting.

sketching fast with bold pencil marks, the artist captures the mood of the moment

Right: baby chicks
media: pen and pencil
Sweet and fluffy, these chicks at this stage belie nothing of their parents' nature.

with just a few lines, cute chicks emerge on the page

Above: strutting hens
media: pencil
These quick pencil sketches really capture the jerky strutting and flutters of two hens.

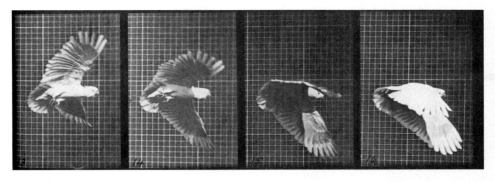

Left: Eadweard Muybridge's "Cockatoo Flying"
media: photograph

In the late nineteenth century, Eadweard Muybridge became a pioneer of sequential photography. His photographs, still widely used by artists today, form an excellent visual reference of the movement of the figure and animal subject.

photograpy and video stills can help if your subject is moving too fast to get anything meaningful down on paper

concentrate on the outline first, then add the details of light and color

Left: bird in flight
media: charcoal and watercolor

Sharpen your visual memory by looking at a moving subject, like a bird in flight, then close your eyes for a moment. Visualize the image in your head, and work straight into your sketchbook.

Below: ostrich
media: pencil

Large birds are inquisitive creatures but highly sensitive. Try to sketch them discreetly and, if you happen to be working among them, keep one eye on your equipment!

Below: flock of birds
media: chalk

Sitting in a park or by the beach will provide you with many opportunities to sketch birds—but you'll have to work fast to capture their image.

bold pencil strokes and hatching add life and texture

flying, strutting, and pecking—all in a few sweeps of chalk

sketching wild animals

Animals and birds are free to roam or fly, so you must let your model take the lead in your sketch work. In doing so, you might find some unexpectedly exciting results. If working from life, don't get bogged down with specific details—you will only become frustrated. The moment you try to render perfectly the contour of a hind leg, your model will probably decide to sit down or simply walk away. Animals are frequently on the move and so you will be obliged to keep your work moving with them. In doing this, your work will convey the restless energy that is the nature and essence of animals.

Working simultaneously on several sketches may be the answer. In some sketches, concentrate on the movement of your subject in line drawings with maybe charcoal or an ink pen. Or, while your subject pauses for a while or sleeps, indulge in the rich textures, colorings, and markings of fur or feather in colored pencil or perhaps pastel.

In the past, artists relied heavily on dead specimens and exhibits from which to make their study. Thankfully, these days, photography and video film provide us with excellent alternatives and can aid the study of the complex anatomical structures. If you set out to make a considered work of an animal it will be worth gathering as much source material as you can for reference.

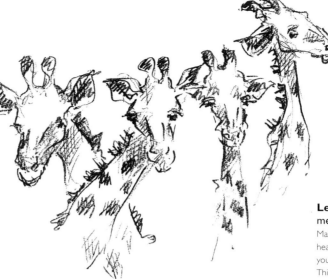

the lively pencil marks and
hatching give the giraffe character

Left: inquisitive giraffe
media: pencil
Making five or six studies of the head of a moving animal will give you several different viewpoints. This will give you some practice in foreshortening and will be useful reference material if you choose to take the study further.

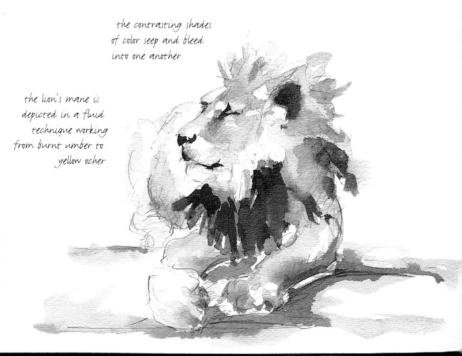

the contrasting shades
of color seep and bleed
into one another

the lion's mane is
depicted in a fluid
technique working
from burnt umber to
yellow ocher

Right: lion basking in the sun
media: watercolor and pencil
Notice how much of the paper is left untouched, with the result that its brightness makes the strongest highlights in this watercolor sketch.

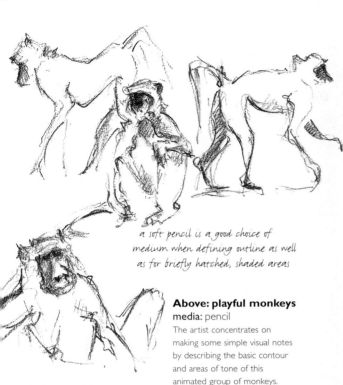

a soft pencil is a good choice of medium when defining outline as well as for briefly hatched, shaded areas

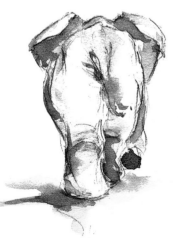

Above: playful monkeys
media: pencil
The artist concentrates on making some simple visual notes by describing the basic contour and areas of tone of this animated group of monkeys.

Below: walking away
media: watercolor and pencil
This amusing sketch of the back view of an elephant trundling away reveals as much about the nature of this beast as seeing him from the front.

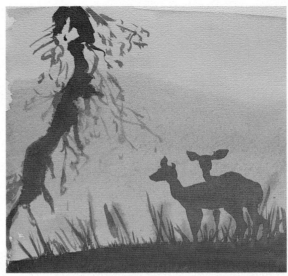

steeped in a mauve light below a pale yellow sky, the welcome coolness of the approaching dusk is beautifully evoked

Above: evening calm
media: watercolor
Silhouetted against a cool wash of watercolor, this sketch shows how much can be expressed through the sensitive use of tone and color alone.

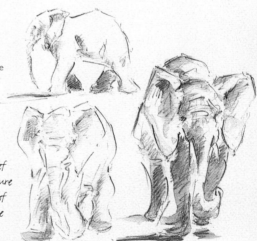

the sketchy pencil marks of these brief studies capture an impression of elephants on the move

the artist has created depth to what is essentially a foreshortened image by adding shadow under the ears and far foot

Tip: *A perfectly studied rendition of an animal poised for action can look as static and dead as a stuffed exhibit— concentrate on keeping your style free rather than detailed.*

Above: studies of elephants
Media: watercolor and pencil
The technique of combining rough pencil sketches with watercolor works well here, particularly on the larger—and probably older— elephant in depicting its rough and wrinkled hide.

109

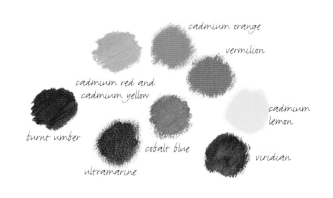

cadmium orange

vermilion

cadmium red and
cadmium yellow

cadmium
lemon

burnt umber

cobalt blue

viridian

ultramarine

CHAPTER 3

from Sketch

In this section, we see how artists with differing styles have used
their visual material and notes to create a finished piece. By using
their sketchbooks to record their experiences and experiment with
ideas, each artist has developed an individual style reflecting a very

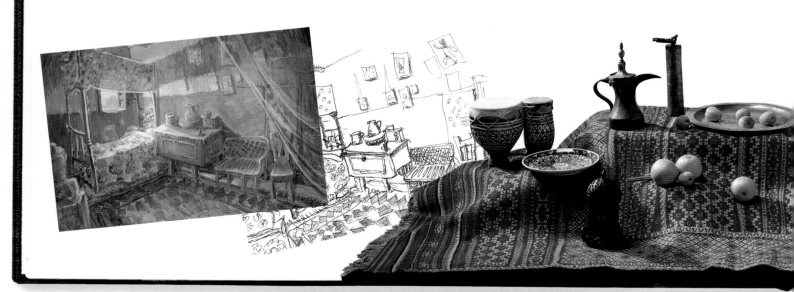

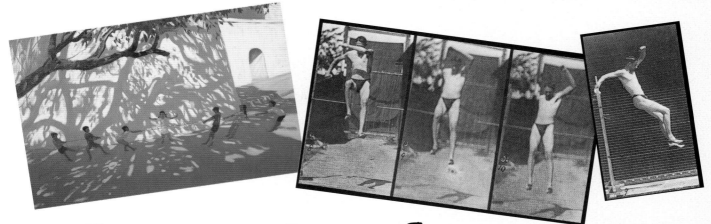

to finished work

personal response to their environment. They reveal how they tackled problems of perspective and composition, and used different media to achieve a variety of effects, such as capturing the ephemeral effects of light and color.

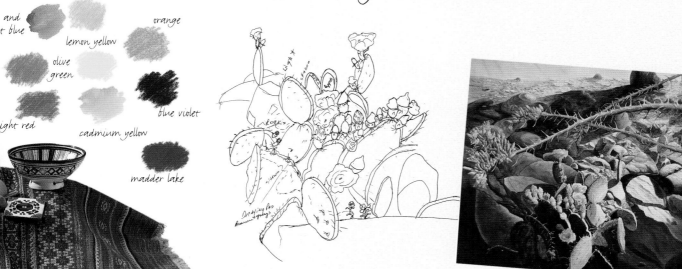

red ocher

light green

and
t blue

orange

lemon yellow

olive
green

blue violet

ight red

cadmium yellow

madder lake

Photography as a tool

The Emperor (feather weight retired) *by Lucy Watson*

Think of using photography not as cheating but as making life easier! When working from life, photographs can provide valuable visual information. Not only are they a good *aide mémoire* for resetting a pose and repositioning drapery, they can also enable much of the finishing of the picture to be completed in the absence of the model, particularly if sitting sessions have to be limited. The aim should be to use photography to gather as much visual information as possible and then use this to supplement your sketches from direct observation.

A good, true-color photograph can provide a useful reference when mixing your palette of colors. One technique to help you perfect your tonal range in these colors is to make a black and white photocopy of the image. This will transform it into clearly distinguishable tones of black and white. Reducing the three-dimensional world to two dimensions resolves difficult perspective relationships and viewpoints. By sketching around the photographic profile of the model, it is easy to see how the size of the head compares to that of the hands in the foreground.

Consider the camera a tool for your sketchbook, and a further springboard for ideas. Many fine pieces of art have been created using photographic reference material alone, but it is only through the experimentation with form and technique offered by sketching from life that you get the chance to develop visually exciting ways to express your subject matter in your own unique style.

Preparatory work

The aim here was to capture the powerful physical presence of the model, an amateur boxer, and to convey something of his slightly menacing don't-mess-with-me aura to the viewer. The visual information gathered would then be used to inform the composition and content of a painting. In the process of sketching a working mock-up, several devices are developed to achieve the end. Decisions must be made on the colors and techniques to be used in the finished work, and there is also the issue of scale, and perhaps most importantly, the composition of the picture.

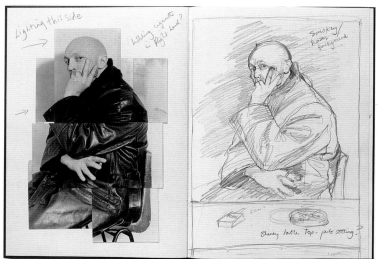

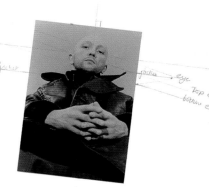

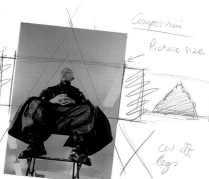

the photographs show how the artist started with a classic side profile pose, making a sketch and photograph montage; the sitter looked pensive and a little sinister in the leather coat, but the overall composition was not sufficiently dramatic

photographs were then taken from a much lower viewpoint, creating a striking composition that put the subject in a powerful, almost dominant position; this compositional change of tack amply demonstrates the fluid nature of sketching and how you can almost entirely reinvent your work at every stage

Skin tone

This photograph on the right was taken outside in bright daylight to capture a true color likeness of the model's skin tone. Careful consideration was given to lighting, making sure that the source of light fell on to the subject from the left, as strong directional lighting from this side would be painted into the finished work.

naphtol red

Payne's gray

yellow ocher

Color swatches showing the basic mixes to complete the flesh areas from the darkest to the lightest tones; it is useful to note your choice of color combinations for future reference and remixing

strong lighting effects can emphasize features you wish to express in your work—here, strong highlights and dark shadows exaggerate the menacing look; the same effect could be achieved indoors with positioned light bulbs

The Emperor

Sketches and preparatory work allowed decisions to be reached on fundamental aspects of the painting.

For the most effective composition, the viewer seems to sit below the model so the form of the leather coat rises from the entire width of the picture's lower edge to create a triangular shape with the head at the apex. The boxer's size has been exaggerated and the ruggedness of his hands locked together emphasize the sense of pent-up aggression. The figure needed to be at least life size and in landscape format to fill the entire field of vision.

a strong color contrast was used, working in a limited color range— mainly black, white, and red—for dramatic impact

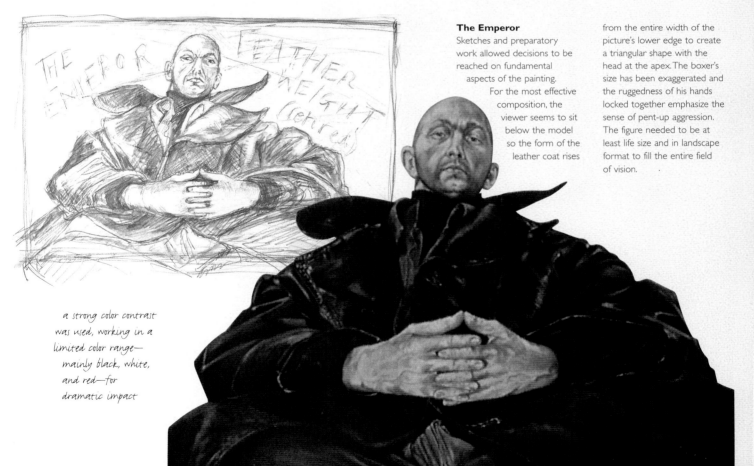

flowers in their element

Light Play, Act XIII
and Morning Song for a Passer-by
by Mary Lou King

Living in Western Texas, on the edge of the Chihuahuan desert, Mary Lou's work is inspired by her love of landscape: "I have a great love and appreciation for the land. It is so spiritual; no mortal constructed it, nor can control it. There is such power and magic. I try constantly to capture the drama and the beauty".

The ever-changing light effects particularly capture her imagination, because they transform the landscape from something soft and seductive to harsh and frightening as they play over the terrain.

The flora, too, is a great source of inspiration; surviving against all odds in the arid desert, it comes to symbolize both the fragility and tenacity of life. Many of the native plants that feature in Mary Lou's work are growing in her yard, so they are always available to study when required. She also keeps a collection of rocks that have appeared in her work over the years.

these photographs of plant life were taken in the back yard and are worked into this painting of a dramatic wilderness scene

scarlet lake
and rose
madder

cadmium
yellow

viridian
green

burnt
sienna

ultramarine
blue

Light Play, Act XIII
The intricately detailed foreground invites the viewer to observe closely the desert flora, while the paler hues of atmospheric perspective behind the rocky outcrop create a sense of space and distance.

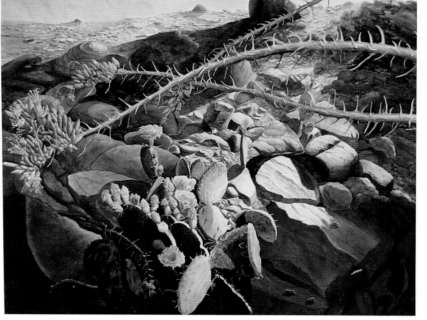

114

the cracks, fissures, and subtle variations of color and tone of
the stone form a dramatic backdrop for the feathered performer

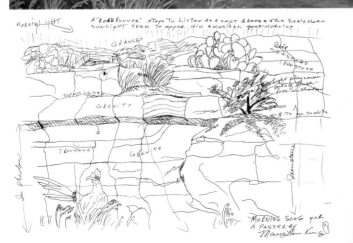

Morning Song for a Passer-by

Mary Lou works on location or from memory back in the studio. For the times away from location she keeps notes, the primary purpose of which are to convey the emotion felt at the scene. She explains that when she has gathered and studied all the information she needs, she puts it all away and goes for a long walk, when the painting will usually appear in her mind's eye. So although the work is informed by reality, it is the powerful imaginative and emotional response to the desert and its flora that provides the starting point for a painting.

burnt sienna and alizarin crimson

magenta and cobalt blue

red ocher

Payne's gray and cobalt blue

yellow ocher and burnt sienna

street scene

Champs-Elysées *by Michael Lawes*

Michael takes photographs of anything that catches his eye. Consequently, he has hundreds of images to choose from and his paintings are made from a combination of photographs, observation, and memory, reconstructed in the peace and quiet of his studio.

Color and reflections have been the principle themes of his work for quite a number of years. He enjoys painting night subjects that allow him to use strong vibrant color to represent artificial light and to explore the effects of reflections on rain-soaked streets. He also likes to use color contrasts, dark against light, warm against cool, bright against dull, and the effects of complementary color.

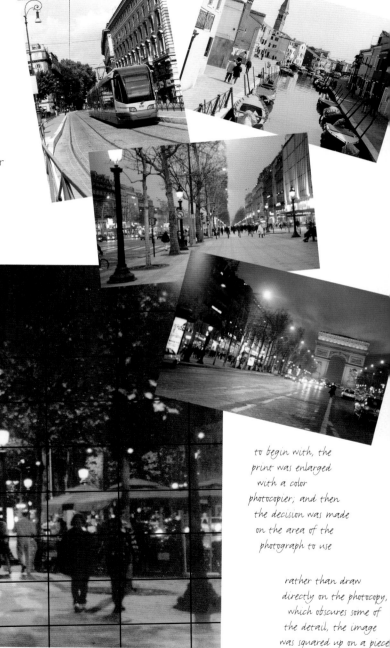

to begin with, the print was enlarged with a color photocopier, and then the decision was made on the area of the photograph to use

rather than draw directly on the photocopy, which obscures some of the detail, the image was squared up on a piece of polythene

willow charcoal was used to produce a simple
outline drawing before adding any color

 light red

 lemon yellow

madder
lake

orange

willow charcoal is very soft
and easily erased so
many different
arrangements of figures
can be tried out without
damaging the
paper surface

to help achieve the wet
evening effect, a full-
size working sketch was
drawn up to allow the
artist to place figures and
reflections accurately and to
determine the colors to use
in the final painting

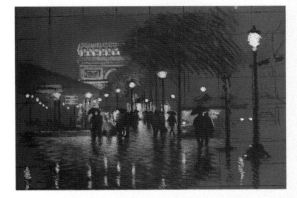

the reflections were positioned with a pale lemon
yellow and the paving areas worked up with ocher
and olive green; a thin layer of white was
added to the reflections with varying pressure

the artist wanted the figures to lead the eye into the
painting and not become focal points—consequently,
the figures have a minimum of detail and are almost
depicted as silhouettes

light
green

blue violet

ultramarine
blue

olive green

Champs-Elysées

Once the arrangement of figures,
reflections, color, contrast, and
composition has been resolved,
the final work can begin. As the
artist explains "This was done
quickly with as little alterations as
possible to retain the natural
freshness of the pastel medium
and hopefully give the picture a
spontaneous feel." He does not
rub or bleed the colors and
dislikes overworked rubbed and
erased pastel surfaces.

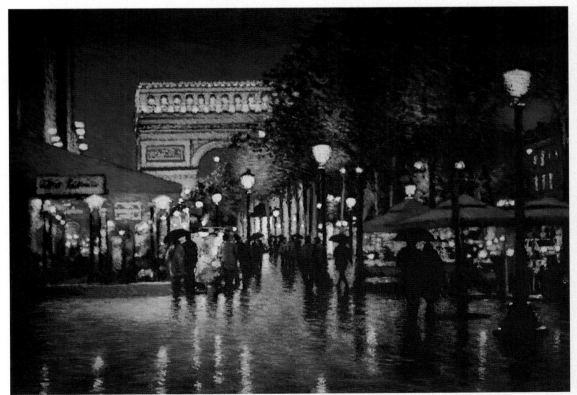

Light and shade

Girl on a Swing and **Tug of War**
by Andrew Macara

In these two paintings, none of the children in the paintings were actually in the location at the time. In fact the girl on the swing was a drawing made in England during the summer in a local park. The tug of war was from a trip to Spain. In both paintings, the subject was not the figures but the interesting patterns of light and shade on the white temple walls. Andrew found the figures in his drawing books after deciding that he wanted something other than just light and shadows.

the artist has many sketchbooks full of several thousand small drawings of people, animals, and interesting objects that have caught his eye

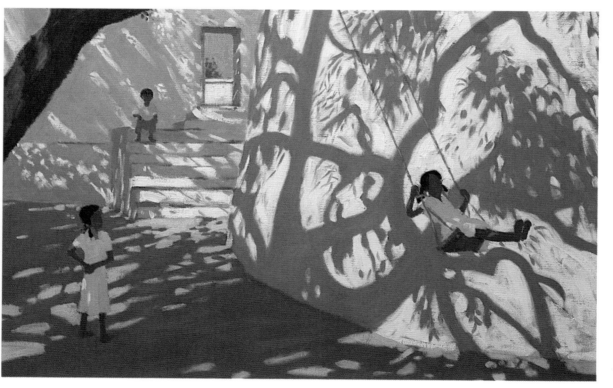

tints of cobalt blue and white

yellow ocher, red, and white

yellow ocher, red, white, and cobalt blue

burnt umber

burnt umber and white

Girl on a Swing
The artist either uses small paintings "made on the spot" which he enlarges and elaborates and/or works from drawings. By holding up his sketches to the light, he can view the figures back to front through the paper, and balance a tricky composition.

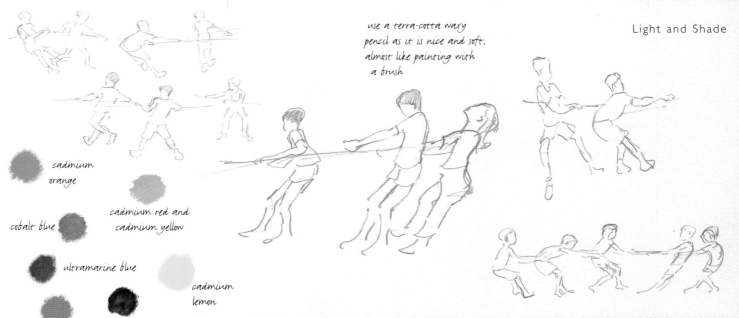

use a terra-cotta waxy pencil as it is nice and soft, almost like painting with a brush

cadmium orange

cobalt blue

cadmium red and cadmium yellow

ultramarine blue

vermilion

viridian green

cadmium lemon

Tug of War

In the studio, Andrew uses charcoal to sketch out the design. It is quick and easy to use, and can be rubbed out and altered. The drawing preparation for a painting only takes five to 30 minutes once the basic idea is decided on. This can then be sprayed with fixative or, as the artist prefers, "go over the charcoal with a pencil, then a cloth to rub away the charcoal. This can then be painted without the charcoal to prevent the colors becoming muddied."

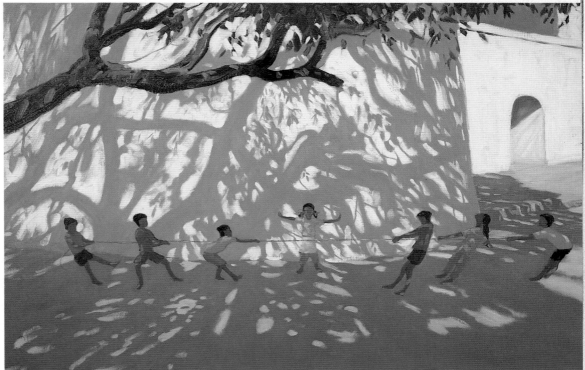

Color as inspiration

Room in Aswan *by Naomi Alexander*

Naomi found inspiration for her work in the light and colors of Egypt: "The blinding light of Egypt was intoxicating. The brightly painted mud houses were one hundred percent my palette coloring." She described in her journal how she was inclined to pull out her pocket sketchbook every few steps, even sketching while walking as the pencil "flew over the page."

On entering a mud house in Aswan, Naomi was struck by the beautiful turquoise blue of the interior, a color she used often in her paintings. This impression of the color blue was to become an important element of the work she envisaged. To add further interest, she organized the composition of the interior to focus attention on particular areas such as the bed and window, and introduced a colorful floor and figure into the painting that weren't originally in the room.

Naomi noted in her journal that she felt conscious about sketching the interior—she was just visiting the house with some friends, her time was limited, and what would the owner think if he caught her sketching? Most artists know that their inspiration will arise at inconvenient times and in the most unlikely places. The urge to get whatever it is down on paper before it disappears can be irresistible, and while sketching a person, scene, or event might appear inappropriate, the action usually provokes nothing more than a fair degree of curiosity. Sketching has the advantage over the camera in that it does not impose the same sense of intrusiveness. Some artists are happy to brazen out inquisitors or, as Naomi explains, at times like these she tries to keep a mental image of a scene in her head, and quickly get it down in her sketchbook before it fades from memory.

Loading a Camel

Sketching an activity quickly before your subject has a chance to move away—such as this camel being loaded—will increase your powers of observation and bring spontaneity to your work.

the walls were turquoise in the light and gray-blue in the shadows

madder lake

burnt sienna and yellow ocher

white and cerulean blue

cerulean blue

yellow ocher

cadmium yellow and yellow ocher

white and madder lake

take photographs and find objects on your trip to use as an aide mémoire back in the studio

busy with pattern and texture, this quick sketch gave the artist enough to work from

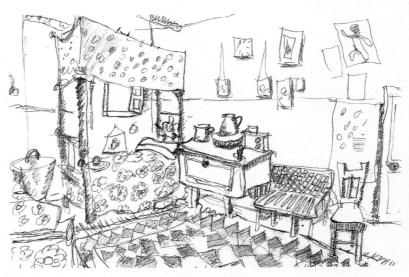

the room was dark but for the light from the window; as the light hit the wall, the color turquoise flooded the room, bringing a feeling of cool relief on a hot, sticky day

Room in Aswan

The net curtain makes a frame so that the picture doesn't wander off the right-hand side of the page. The left-hand side is darker in color so that your attention is focused in the middle of the painting.

the pattern on the floor was made up to elaborate on the busy feel of the picture; there was no one in the bed either—this was added to give extra interest

121

Your sketchbook as a travel diary

The Carpet Souk *by Valerie Warren*

Valerie, a prolific traveler, never fails to take at least one sketchbook and a selection of pencils and ink pens on a trip. The clean lines of her many sketches provide her with a good starting point to take her ideas further into paintings back at home. And these travel diaries make wonderful, visual mementos of an exciting visit abroad.

On this trip to Marrakesh in Northern Morocco, Valerie had a variety of opportunities to sketch landscape, people and buildings: during the wait at the airport, the view of the Atlas mountains from her hotel room window, in the many different restaurants, cafés, and luscious gardens, and in the main square and souk.

The shadowy alleyways and colorful market stalls of the souk—especially the carpet souk—gave Valerie the idea to produce a small series of paintings when she arrived back home. Taking the line drawings she had created on her trip as a guide—plus photographs and various purchases from the souk—Valerie was able to recreate in her mind the vibrant buzz of the North African city. You may find that the atmosphere, architecture, or color seen or felt during your visit make the greatest impression, and there is no reason why they shouldn't be the main focus of your work.

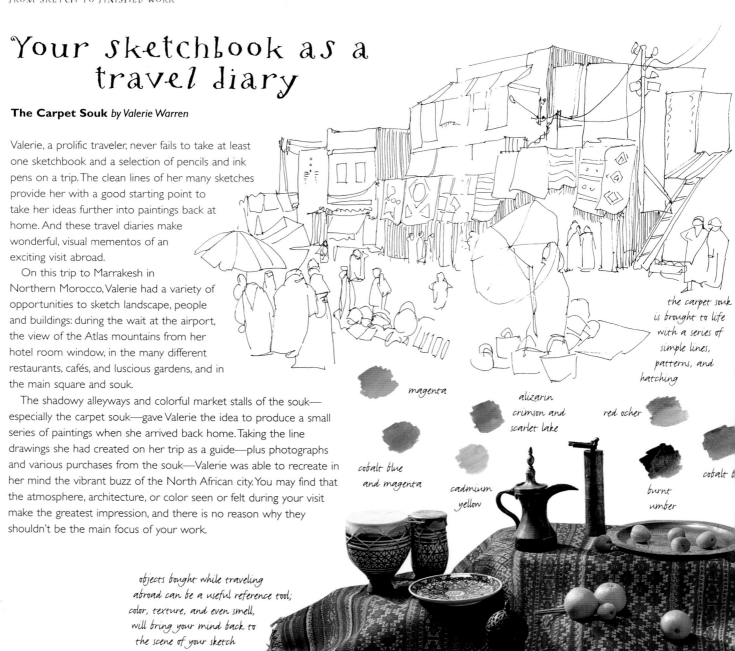

the carpet souk is brought to life with a series of simple lines, patterns, and hatching

magenta

alizarin crimson and scarlet lake

red ocher

cobalt blue and magenta

cadmium yellow

burnt umber

cobalt b[...]

objects bought while traveling abroad can be a useful reference tool; color, texture, and even smell, will bring your mind back to the scene of your sketch

122

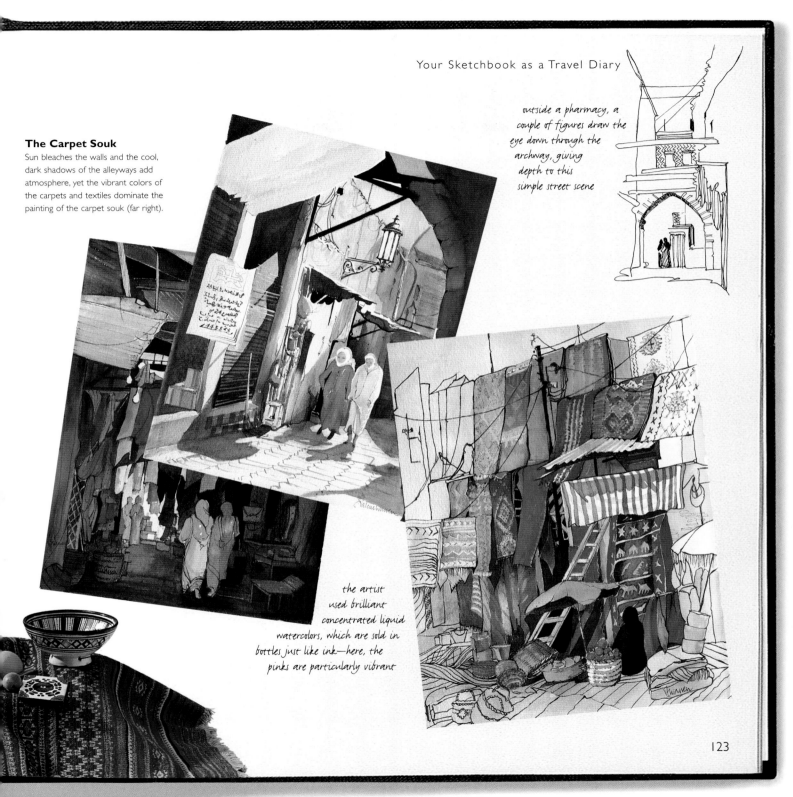

The Carpet Souk

Sun bleaches the walls and the cool, dark shadows of the alleyways add atmosphere, yet the vibrant colors of the carpets and textiles dominate the painting of the carpet souk (far right).

outside a pharmacy, a couple of figures draw the eye down through the archway, giving depth to this simple street scene

the artist used brilliant concentrated liquid watercolors, which are sold in bottles just like ink—here, the pinks are particularly vibrant

123

Perspective and structure

Pool I *by Lucy Watson*

This swimming pool featured in German archive film footage from the 1930s. The pool itself probably no longer exists, but this structure—with its grid-like construction that contrasted with the ephemeral qualities of natural light and water—so caught my imagination that I freeze-framed the video player and made sketches directly from the television set. While I worked, it became apparent that the dazzling light flooding in through the glass walls and ceiling was as important a part of the structure as the criss-crossing iron beams. My aim was to break down the severe perspective of edges and angles of the structure with the brightness of natural light, and to play the contrasts of man-made form against the reflections of light and water.

After several attempts, I found it difficult to achieve the translucent effects I desired using my usual working materials of pen, pencil, and watercolor, so I looked for different and experimental ways of tackling the challenge. I melted some wax onto Japanese paper, then overlaid this with a sheet of newspaper and applied a hot iron to the surface to

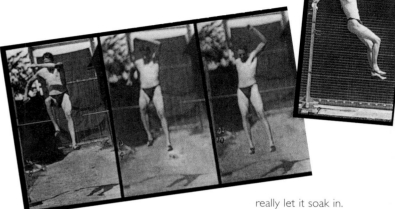

really let it soak in.

Once it had cooled, the paper took on a wonderful translucent quality that provided the ideal base for the effects of reflected light and water I was trying to capture.

The original documentary film source was in black and white so I brought my own imaginary color to the scene, trying out just one or two different colorways with oil pastels. I then "scratched" out the structure of the building and its reflections with the blunt nib of a dip pen. Although this method took a little time and effort, I found that my preparatory sketches were not only extremely useful for reference in the painting, but also became small finished works in themselves.

The image of the pool alone looked rather like a technical exercise in perspective, so I decided to introduce a human presence to the scene by adding some figures. The few figures I included appear almost incidental, but this emphasizes the sense of man's vulnerability within such a vast structure, and brought a sense of scale to the work.

the preliminary sketch was created by layering wax between Japanese paper and newspaper, and then scratching into oil pastels with a blunt nib

sketches for the figures were made from Eadweard Muybridge's anatomical photographs of men walking and jumping over hurdles (left)

Payne's gray

ultramarine blue

ultramarine blue and titanium white

burnt sienna

Pool 1

This painting was created by collaging different sources together. It is called *Pool 1* as the artist still remains intrigued by the subject and feels there is more mileage to gain from it yet. She was pleased with the photographic "negative" effect of the image in her initial wax sketch, so this might become *Pool 2*, and who knows where this may lead— perhaps to *Pool 3* and *4*—a case where creating a piece inspires further work.

here, Payne's gray is enriched with ultramarine blue to create deeper tones in the reflections and areas of shadow; the artist contrasted this with areas of titanium white to convey the brightness of the exterior light; to create an underlying warmth, the canvas was underpainted in burnt sienna letting just hints show through

125

Index

Credits

Quarto would like to thank and acknowledge the following for supplying pictures reproduced in this book. All other pictures are the copyright of Quarto Publishing plc.

Key: l left; r right; c center; t top; b bottom

Alexander, Naomi p5br; p9tl; p46tr; p58bl; p59tl; p67tl; p68t; p71tr; p72t, c & b; p82tl; p86t; p89t; p95br; p105r; p106tr; p110bl; p120/121; *Amsterdam-Farley, Elaine* p63r; *Arbus, David* p23t; p59tr; p68b; p70bl; p71l; *Baitey, Jean* p104bl p106c; *Beesley, Mark* p24b; *Bewsher, Steven* p24c; p103c; *Bolton, Richard* p27tr & cl; p41l; p56/57; *Brandt, Bob* p41b; p48b; p75tr; p93tl; *Cassels, Julia* p3; p4; p8bl&r; p9bl; p39tr; p61tr & tl; p88t; p90/91; p107c; p108/109; *Castelli, Marc* p50tr; p51tr; p53r; p7ot; *Clinch, Moira* p63bl; *Coppillie, Robert* p5tr; p54t ,c & b; *Ferbert, Mary Lou* p42t; p62; p65bl; p67r. *Hampshire, Sophie* p85b; *Harris, Lindsay* p60br; p73tl & bl; *Hobbs, James* p40tr; p42b; p44t; p66t; p69b; *Holmes, Walter* p20t; p40bl; p47b; p63tl; *Jackson, Malcolm* p16t; p22t; p27b; p82c; p86br; p89b; *Jordan, Maureen* p6tr; p20l; p30b; p35b; p74bl; p84t, c & b; p92bl; p98r; *King, Mary Lou* p111b; p114/115; *Lacki, Melanie* p1, p39bc; p100/101; *Lawes, Michael* p116/117; *Linton, Nicolette* p64br; *Macara, Andrew* p83b; p86bl; p87r & b; p89tl; p107bl; p111tl; p118/119; *Marsh, Gaynor* p38tc; p64tr; p65br; *Martin, David* p96b; *Millsted, Mark* p8t; 13tr; p50l; p103br; *Mueller, Ned* p9r; p79r; p80bl; p81tl; p85tr; p92br; p93r; p97l & b; p98bl; *Oliver, Alan* p.39tc; p106tl & bl; *Relfe, Liz* p13r; p28t & b; p29t; p30t; p103bl; *Russell, Christine* p61c; p105bl; p40br; *Rubens, Sula* p19b; p29 b; p105tl; *Rubens, Zoe* p43; p87t; *Solcyk, Phyllis* p67tr; *Stewart, Charlotte* p35t; p82bl; p88c & b; *Sutton, Andrew* p34t; p52cl; *Thomas, Gill* p39tl; p66b; *Thomas, Glynn* p41tr; *Thomas, Ray* p67b; p73r; *Ungoed-Thomas, Roland* p19t; p21; p82tr; p104t; *Warren, Valerie* p39bl; p44b; p45b; p48tr; p122/123; *Watson, Lucy* p5tl; p18l; p24t; p25; p27c; p31b; p32l; p33t; p38tr; p39br; p49t & b; p50cr & br; p55tc; p60tr; p74tr; p75t; bl & br; p76; p77; p78t & b; p80t; p81b & r; p85tl; p94; p95t & b; p97tr; p99l & r; p102; p103tl; p104br; p107br; p107tr; p112/113; p124/125; *Wells, Paul* p6tl; p54bl; p55l & tr; *Whittle, Janet* p7tl; p27tl & cr; p38b; p55br; p58tr; p59b; p61b; p63l; *Woods, Jim* p2; p6b; p7b; p38tl; p46.

While every effort has been made to credit contributors, Quarto would like to apologize should there have been any omissions or errors.